Pablo Picasso

Titles in the series Critical Lives present the work of leading cultural figures of the modern period. Each book explores the life of the artist, writer, philosopher or architect in question and relates it to their major works.

In the same series

Michel Foucault
David Macey

Jean Genet
Stephen Barber

Frank Kafka
Sander L. Gilman

Pablo Picasso

Mary Ann Caws

REAKTION BOOKS

Published by Reaktion Books Ltd
79 Farringdon Road
London EC1M 3JU, UK

www.reaktionbooks.co.uk

First published 2005

Printed and bound by Cromwell Press, Trowbridge, Wiltshire

British Library Cataloguing in Publication Data
Caws, Mary Ann
 Pablo Picasso. – (Critical lives)
 1. Picasso, Pablo, 1881–1973 2. Painters – Spain – Biography
 I. Title II. Picasso, Pablo, 1881–1973
 759.6

ISBN 1 86189 247 0

Contents

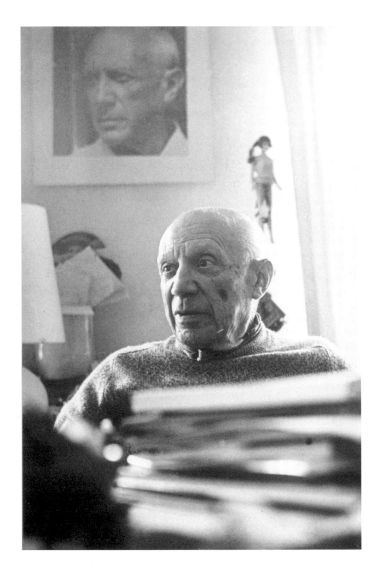

Introduction

Arthur C. Danto

The lives of heroes can take the form of chronicles of high deeds – of the memorable victories and the great overcomings, and, of course, if the hero is tragic, of defeat and death. If the heroes are artists, the available alternative form might be the retrospective exhibition, in which the great works – the masterpieces – define, like the profile of mountain ranges, the peaks and valleys of break-through and achievement, failures if there were failures, and recoveries. But neither form tells us much about the life of the hero as something lived – what it was like to have been him or her. Heroes are human, after all, or, to use Nietzsche's phrase, human, all too human: composites of body and soul, with needs and dependencies: parents and siblings, teachers and mentors, friends and enemies, lovers and rivals, children, doctors and retainers, even horses and dogs. We can imagine a life told through the medium of habitations – birthplaces and resting-places, and the gazetteer of countries and cities that left their marks on the hero's evolving soul. Picasso's biography, ideally, is a library of each kind of volume – where he lived, when and with whom, as well as all the sketches and masterworks, the influences upon him and his impacts on others, and the differences it made that he lived and created what he did when he did it. It is hard to imagine a nutshell format, in which it can all be told at once. A volume of mispercep-tions can tell us as much as one consisting only of the truth and nothing but the truth.

Mary Ann Caws has wisely chosen the format of the 'bande à Picasso' – the group of *copains* that formed the Picasso circle early on, which for that reason differs from the gallery of his women, who replaced and succeeded one another, and could not have formed a company, since they came on the scene at different stages of the artist's life, bringing into it different families and, as women will, different styles of life. I say wisely, for the hero with his band already has the aura of a myth – of King Arthur and his knights, Robin Hood and his Merry Men, Socrates and disciples. What is striking is that the 'bande à Picasso' had no painters in it, as well as no women, though painters and women were certainly part of Picasso's life at every stage. The band was made of up of poets, the studio in the legendarily rickety architecture – the Bateau-Lavoir on Montmartre – was a gathering place for poets, and said as much on its door. Picasso and his art were their subject as well as their criterion, and it is fair to say that Picasso and their relationship to him was the substance of their life as thinkers and writers. They were Max Jacob, André Salmon and Guillaume Apollinaire, although others came and went. One can think of the life on the model of an opera, with Picasso as hero surrounded by a chorus of poets. The setting is a studio. Paintings lean against the walls. The company eats a frugal repast in front of *Les Demoiselles d'Avignon.* A dog sleeps under the improvised table. Fernande Olivier sleeps under Moroccan blankets. As the opera plays itself out, the scene changes. In Act II, perhaps, *Guernica* has replaced the *Demoiselles*, Dora Maar has replaced Fernande, Cocteau has joined the chorus, Picasso is bald, there is a new dog. But the form of life is essentially unaltered. The Bateau-Lavoir was the default condition of Picasso's life, the place, as he later acknowledged, where he was happy; the place, finally, where he was Picasso.

Caws's operatic choice, as I think of it, was astute, for it enables her to bring into the discussion her unmatched knowledge of French poetry and literary movements. And it makes evident for the reader

how, more than the life of any major artist of modern times, Picasso's was a life of literature. In addition to the poets of the Bateau-Lavoir, there were Blaise Cendrars and Gertrude Stein, René Char and André Breton. Nothing remotely like this was true of Picasso's only true peer as a painter, Henri Matisse. Bloomsbury was a mix of painters and writers, but not even Virginia Woolf was the solar centre of others, following their own orbits. The New York Poets formed a circle around Fairfield Porter, who lacked a heroic dimension. In the end, the chorus defined the hero in the operatic life of Picasso, and Mary Ann Caws has written its proto-libretto. It is a life of the artist unlike any other.

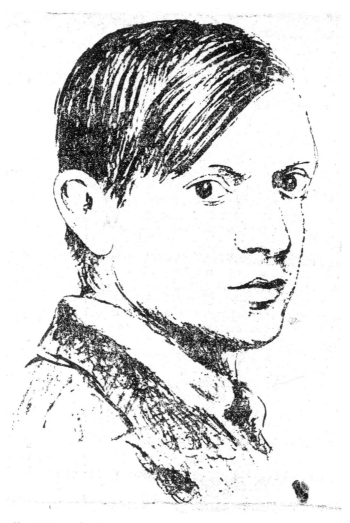

Self-portrait, 1901, drawing.

1

Introduction

The important thing is to do, and nothing else; be what it may.[1]

Rather than giving an already familiar and extensive recounting of the places and people in the famous life of Picasso, this brief study will concentrate on a few of its high points, as the present writer sees them. Instead of chronicling in detail, as the standard biographies do, his changes of locations for living and painting, his paintings in their chronological order, and the names and dates of his exhibitions, gallery showings and sales, it will take up those topics as they feel appropriate to the text, and expand upon only those that seem relevant to my focus.

For in particular I want to stress Picasso's all-important relationships with his close friends. It seems to me that in looking at these from closer up than can usually be the case in standard biographies, we are now able, in the twenty-first century, to gain a slightly different view of this monumental figure of the twentieth century.

Both lauded and criticized for his changing styles – a nomad within his own paintings – Pablo Picasso was from the beginning a self-aware performer, and not an especially modest one. 'God has no style', said he. So why should Picasso? *Yo soy el rey*, we read under an early self-portrait. I am the king. Or, more simply, 'Yo, Picasso'. That says it all, and justifies – at least from Picasso's point of view, which is, after all, not an entirely misplaced one – his shifting styles, the subject of so much discussion. His juggling of

viewpoints, artistic strategies, loves and friends can be seen as part of the inevitable expansion of his genius and his personality. Admired, envied and no less detested for his feats, he exemplifies a certain brilliant modernist personality magnified into an iconic being and model with all his contradictory tendencies: his unusual generosity in friendship on the one hand, and, on the other, a manifest cruelty, at the opposite pole from his tenderness.

We have only to listen to Picasso's interviews with the French writer André Malraux to hear the personality loud and clear. It comes through whatever guise he threw himself into. Playing as well as depicting the characters of the acrobat or Saltimbanque and the jester or Harlequin, characters from popular entertainment such as the circus and the Italian *commedia dell'arte*, throughout his own life, Picasso was in constant motion, hurling himself into ring after ring, triumphant over the ordinary and celebrating the intensity of work, work, work, as of love. 'One must do everything, on condition that one never does it again.'[2] His self-esteem was nothing if not entire: here he speaks with Malraux in his characteristically modest guise: "'Down with style! Does God have a style! He made the guitar, the Harlequin, the dachshund, the cat, the owl, the dove. Like me . . . He made what doesn't exist. So did I. He made paint. So did I.'" Picasso's penchant for disguises was no less intense than his love of work and women, and increased as the years went by. So we see him adopting costume after costume – the clown and the monkey, the Spanish Dancer and the acrobat, combining in himself all the roles that interested him.

The Harlequin figure of the *commedia dell'arte*, not unlike the clown of Picasso's 'Blue Period', comes nearest to capturing the particular anguish and sentiment of the Picasso now familiar to us. Picasso's relation to the circus was always important: one of his first liaisons was with Rosita del Oro, a horsewoman at the Tivoli-Circo d'Equestre, in Copenhagen, at the beginning of the twentieth century. The immense appeal of the family of acrobats in his

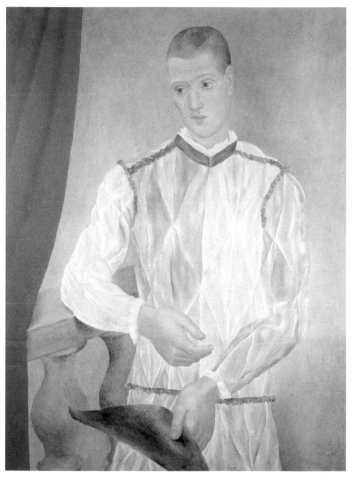

The Harlequin of Barcelona, 1917, oil on canvas.

paintings, some with the sad face of Carles Casagemas, Picasso's close friend who committed suicide in 1901, was demonstrated at an exhibition in Paris at the Grand Palais in 2004, simply called *Parade*. Picasso's *The Harlequin of Barcelona* of 1917, and his *Salvado the Painter as Harlequin* of 1923 (Centre national d'art et de culture

Georges Pompidou, Paris), stress the closeness of this figure to his being. Jean Clair, in a lecture called 'The Artist as a Clown', described the clown and Harlequin figure as both touching on the lightness of marginality, free in the world of marvels and monstrosity from the conventions of society.[3] Here all the rituals of order and disorder, the myths of creation and the contrasts – dwarfs and giants, exultation and sacrifice, balance and off-balance – link heaven and the everyday, as in the origin of the term 're-ligion', *re-ligere*: the link between earth and sky. The Saltimbanque conjures death by juggling, and that kind of innocence and monstrosity combined remind us of one of the superb prose poems of the French Symbolist poet Charles Baudelaire, 'The Old Mountebank': before a joyous holiday crowd, a spectacle is furnished by mountebanks and acrobats. The narrator tells of wanting to give something to the old performer in his poverty, but then the crowd drags him away:

And as I went home, obsessed by this vision, I tried to analyse my sudden grief, and I said to myself: I have just seen the image of the old man of letters who has outlived the generation he so brilliantly amused; the image of the old poet who has no friends, no family, no children, degraded by his poverty and by public ingratitude, and into whose booth the forgetful world no longer wishes to enter![4]

Picasso, clown and Harlequin, in all his various disguises, with all his various points of view and styles and subjects, with halo and rags, has reigned supreme in many minds and many markets. On 5 May 2004 his painting of the adolescent known as *P'tit Louis* from his 'Rose Period' sold for the highest price ever paid for a painting at an auction: lyric, poetic, as John Richardson describes it, and clearly appealing to something in our contemporary minds.

Picasso's oversized emotions and his accepted standing as first among painters might well have seemed a turn-off to friendship as

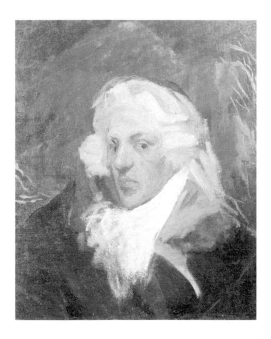

Self-portrait as an Eighteenth-century Gentleman, 1896, oil on canvas.

to admiration: 'I have no real friends. I have only lovers! Except perhaps for Goya, and especially Van Gogh.'[5] And yet it turns out that he had, especially in the exciting early years, friendships with poets and writers that would be unparalleled, and the envy of many. In this, as in much else, Picasso stands out as distinct from other painters – his friendships are celebrated, as are the friends themselves. It is all part of his oversize legend and of his truly oversize life.

Various biographers have chosen various manners of dealing with the oversize. Elizabeth Cowling's highly informed work breaks off the discussion in the 1940s, marking the German occupation of Paris, Picasso's declaration of membership in the Communist Party and his move down to the south of France. In his gigantic and masterful performance of a biography, John Richardson repeatedly emphasizes Picasso's *mirada fuerte*, that intense gaze levelled on

everything around him. He saw much and hard, conquered everything he saw: objects and women, friends and canvases. And yet his obsession, from the start, was that of the final encounter, with death. So one might interpret his various disguises and feints as a kind of play against its immense reality. Anecdote after anecdote spells out this attitude: his dislike of the idea of making an elegiac monument to his beloved friend, the poet Apollinaire, his absence from Matisse's funeral.

To recount the well-known facts of Picasso's life is to recount how the juggling of all those objects and loves and styles somehow composed an art that was of a perfect if strange coherence, relating to a wide number of fields and persons, due to what the American writer and collector Gertrude Stein aptly called his 'emotional leap and courage'. He did not perform alone – above all, his literary friends were his companions in his effort not 'to slow himself but to concentrate himself'.[6] And some companions they were: at the beginning, Max Jacob, Guillaume Apollinaire, Pierre Reverdy, André Salmon; then Jean Cocteau, and Paul Eluard, André Breton, Michel Leiris; later, writers as dissimilar as Clive Bell and René Char. Not that artists were absent from his life: Juan Gris and Georges Braque and Henri Matisse, of course. But as Stein once remarked, he chose to befriend writers because they were what he needed:

> He was in Paris. His friends in Paris were writers rather than painters, why have painters for friends when he could paint as he could paint . . .
>
> He needed ideas, anybody does, but not ideas for painting, no, he had to know those who were interested in ideas, but as to knowing how to paint he was born knowing all of that.[7]

Much has been made, quite rightly, of the role of women in Picasso's life and for his art. Each change of mistress or wife occa-

sioned a change of style, it is often said. In any case, the models for the works are clearly distinguished, and have been widely commented upon. Equally, the relations between Picasso and Braque, during the Cubist era, and Picasso and Matisse have been given their rightly deserved discussions: after Matisse's death in 1954, Picasso had no one he found as worthy and as interesting to talk about art with. Matisse had his own point of view about the younger artist, whose changes of style and manner wreaked such havoc in his reception at the time, and have continued to. What excess, some say, what an inconstancy, what a unique discontinuity says John Berger. What a problem artist, says James Elkins. And Matisse, to Françoise Gilot, about Picasso's visit to him: 'He came to see me, and he hasn't come back'. 'He saw what he wanted to see – my works in cut paper, my new paintings, the painted door, etc. That's all he wanted. *He will put it all to good use in time.*'[8] At this point, Françoise remembers Picasso saying: 'When there's anything to steal, I steal.' His finding something to borrow or steal was, of course, a fine compliment – which the recipient may have enjoyed less than the visiting artist.

Such eclecticism and such extreme 'borrowing' or taking were not always deeply appreciated, particularly in France, where it was often seen as a sin against *le sérieux*, a kind of earnestness and devotion, completely the opposite of what irritated many as a dilettantish jumping from one thing to another. See, for example, Robert Delaunay's criticisms – that Picasso's eclecticism was stealing (*pillage*), that his personality was made up of 'superficiality', 'snobbery' and 'lack of seriousness',[9] or that of John Berger, in his *The Success and Failure of Picasso*, generally so enlightened about art and artists, who accuses Picasso of developing only from 1907 to 1914, during the Cubist period. Still worse on the accusation scale is Pierre Courthion, writing in the *Gazette des Beaux-Arts* about Picasso's 'incessant squandering. The artist has stockpiled his ditherings in an ever more rapid succession of changing concepts

and styles . . . This modern-day Proteus, this denizen of Babel, has sinned through excess of rhetoric, above all through excess of improvisation.' In fact, continues the critic, his 'impatient experimentation' marked him as a non-French, non-serious, dabbler.[10] Cowling points out the racist slant to this: as an exiled Spaniard (never mind that the exile lasted so very long, and that Picasso chose to remain, live, work and die in France), Picasso quite evidently lacked French clarity and, graver even, moderation. Ah, this was the mixed-race essence of him, this restless inheritor of Judaeo-Arabic values!

One of the reasons for the present study is exactly that restlessness, that frequent change of scenery and of enthusiasms. For me, they are a large part of the interest, as are the inhabitants of Picasso's various atmospheres and circles, often compared to the Spanish *tertulia*. Each group of characters and scenes has a separate chapter, dividing up the 'periods' of his art. It goes without saying, of course, that there are no absolute boundaries, and that the persons, places and works have in general their ongoing importance in more than one period, with the boundaries flexible, the planes (as in the Cubist notion of *passage*) slipping over one another, in the kind of 'Analytic Cubism' shown in Picasso's landscapes of Horta del Ebro in 1909, where his Barcelona friend Pallarés had invited him. Barcelona remained essential in Picasso's mind and work.

For the early period in Barcelona, say from 1898 to 1903, the central entity was the café Els Quatre Gats. For his establishing himself in Paris, say from 1904 to 1906, at the Bateau-Lavoir, it was Max Jacob, his most intimate friend – they even shared a top hat. Gertrude Stein began to acquire his works, and he painted her in a famous portrait. Fernande Olivier was his companion at these times, and her memoir speaks tellingly of them. In the period around 1907, of capital significance in the world of art and culture that we call Modernism, it was Picasso's *Les Demoiselles d'Avignon*. For the Cubist period, say from 1908 to 1915, in which Georges

Braque and Juan Gris were ever present, and in which he was involved with Eva Gouel, the capital figure was, in my view, Guillaume Apollinaire. On Picasso's deathbed, he murmured Apollinaire's name, so he was present to the end. In the period 1916 to 1920, Jean Cocteau was instrumental in bringing Picasso into the circle of Diaghilev and the Ballets Russes, where he met his future wife, Olga Koklova. From 1921, when he began to counsel Jacques Doucet so insistently to acquire *Les Demoiselles d'Avignon*, up until 1935 or thereabouts, a central figure was André Breton, who determined to bring Picasso into the Surrealist orbit (as he continued to do until 1944). Marie-Thérèse Walter, whom he met in front of the Galeries Lafayette when she was aged 17, entered his life at this point. From 1936 Paul Eluard was Picasso's close companion, through the terrible event of the Fascist bombing of the little Spanish town of Guernica and his painting of it, until 1944, when Picasso joined the Communist Party and made his *Man with a Sheep* and his famous dove of peace. Eluard, also a Party member, had introduced Picasso to the photographer Dora Maar, who became his companion and photographed the stages of *Guernica*. It was at this point, at the end of the war, that the relations between Breton and Picasso were severed, because of their opposed political stands: Breton remained a Trotskyite. Françoise Gilot replaced Maar in Picasso's affections, and Maar's scribbled and rewritten poetry about her life with Picasso dates from after his leaving her. Eluard died in 1953, and in 1954 Picasso started his celebrated series: first, of a set of reactions to Delacroix's *Women of Algiers*, and then, in 1957, *Las Meninas*, after Velázquez.

This was the period of Roland Penrose, instrumental in Picasso's exhibition in London in 1958 and of Picasso's relation to the Bloomsbury group, and his friendship with the art critic Clive Bell, which continued from the 1920s until Bell's death. From shortly thereafter dates his enthusiasm for pottery and for the little town of Vallauris, where he met Jacqueline Roque, who then became his

wife. The last chapter concerns the period starting in the late 1960s and early 1970s, the time of the Avignon exhibitions, full of black paintings. It was at this time that André Malraux wrote his account of Picasso, and René Char penned 'Picasso sous les vents étésiens', the preface to the exhibition catalogue of Picasso's works from 1970 to 1972, which was published on 15 May 1973 by GLM (Guy Levis Mano). The 'vents étésiens' were the summer winds near Mont Ventoux, on which Picasso and Char had been pictured together, protesting against the nuclear installations on the mountain. These were the two giants of the period: the painter and the poet, the first in exile from Spain, however self-imposed, and the second, somehow also in exile, forever different from the world of non-poets, like another Orion landed here, among men.

2

Picasso the Spaniard

I represent Spain in exile . . .

Picasso, to the Cuttolis[1]

Pablo Ruiz Picasso, the first child of Don José Ruiz Blasco and Doña
Maria Picasso y López, was born on 25 October 1881 in Málaga,
where his father taught drawing at the School of Fine Arts. His two
sisters, Lola (1884) and Concepción (Conchita, 1887), followed. After
his father had moved the family to the coastal town of La Coruña,
where he taught at the secondary school, Conchita died of dipthe-
ria, in 1895, when Picasso was 13. He had vowed, if she lived, to give
up painting.[2] A tragic sense of life, like the Spanish philosopher
Miguel de Unamuno's classic *Del sentimiento trágico de la vida* (1913),
hung always over Picasso, throughout the jovial friendships and
the clowning about.

Despite his many years in France, from his early pilgrimage
there in 1900 with his friend Casagemas, to his establishing himself
in Paris, first with Max Jacob and then in the Bâteau-Lavoir, and
in all the subsequent locations, to his death in Mougins, Picasso
always thought of himself as a Spaniard. 'Yo, Picasso' was never a
Frenchman, and he signed himself 'Picasso artist-peintre español'.
Much has been said about Picasso's ultimate Spanishness, and about
his displacement, a kind of self-exile, first to Paris and then to the
south of France, as if remaining on the border, near Spain, always
longing to return, like Goya, to whom he is so often compared.

Early in Barcelona he found his place and frequented it. In his discussion of this period, Cesareo Rodriguez-Aguilera's *Complete y veridica historia de Picasso y el cubismo* of 1975 stresses the convergence of many elements that we instantly recognize, along with Picasso's essential Spanish consciousness – 'Spanish Moor and Moorish Christian and Roman citizen and unfathomable Iberia' – these were the four genes stimulating each other. Such an elemental variousness goes some way towards explaining Picasso's worldwide renown: the painter with the immense variety of styles had a no less various being.

Never was there a question about his talent: from a young age, he triumphed over all the exams in all the academies of Beaux-Arts, finishing perfectly in a day what it took the others a week to do badly. And Picasso never questioned his talent either: 'Yo soy el rey'. At the School of Fine Arts in La Coruña, he took first the drawing and ornament class, then the life-drawing class, and kept all his early journals with caricatures and drawings from plaster casts, signed P. Ruiz. Later, he gave up his father's name, Ruiz, and kept his mother's, Picasso. According to one anecdote, at one point his father turned over his palette, brushes and colours to him, acknowledging him to be a finer artist. Picasso did not disagree.

In 1895, on a trip to Madrid, he first saw the paintings that would so influence him, by Velázquez, Zurbarán and Goya. That year the family moved to Barcelona, to the calle Cristina. Here Picasso's father was to teach at La Lonja, the Academy of Fine Arts. Picasso apparently took all the exams for the academy in one day, and was accepted. In the exhibition of 1896 in Barcelona, his *First Communion* (1895–6; Musée Picasso, Barcelona) was shown, alongside paintings by the men who were to become his friends at the bistro Els Quatre Gats: Santiago Ruisiñol, Ramón Casas and Isidro Nonell. Academic in style, something about its drama was startling for a 15-year-old – the white of the communion dress vivid against the sombre setting – and the young painter was noticed immediately.

At this point, Picasso was drawing intensively, making portraits of friends and family. The following year his second large academic painting, *Science and Charity* (1897; Museo Picasso, Barcelona), was shown in Madrid, during the national exhibition in June, and then won a gold medal in a Málaga competition. His first solo exhibition was in the Sala Gran of Els Quatre Gats itself, in February 1900, and his friends there formed a firm support group for the young painter. Among many others, these included Ricardo Canals, who with his wife was a great friend of Picasso also in Paris – the connections between Barcelona and Paris were frequent, especially for Picasso. He would always return to the bistro whenever he was in Barcelona, between his trips to Paris, and even when he eventually moved to France, in 1904. It was his artistic home.

Located in the Casa Martí at 3 calle Montsió near the Portal del Angel, Els Quatre Gats ('Es serveix beure y menjar a totes hores' / 'Here you can eat and drink at all hours') was founded in 1897. The name, which means 'only a few people' in Catalan, was also a reference to the 'four cats', that is, Pere Romeu, Santiago Rusiñol, Ramón Casas and Miguel Utrillo, all of them interested in the Parisian bistro Le Chat Noir or The Black Cat, where Utrillo had put on shadow plays – *les ombres japonaises* – with cut-out figures. Picasso's design for the two metal cats suspended as a sign outside cleverly managed to connote four cats, since they were painted in grey on one side and black on the other. Ruisiñol's initial invitation to the public read:

This stopping place is an inn for the disillusioned; it is a corner full of warmth for those who long for home; it is a museum for those who look for illuminations for the soul; it is a tavern and stopping place for those who love the shadow of butterflies, and the essence of a cluster of grapes; it is a gothic beer hall for lovers of the North and an Andalusian patio for lovers of the South; it is a place to cure the ills of our century, and a place for

friendship and harmony for those who enter bowing beneath the portals of the house.[3]

Els Quatre Gats was the home of 1890s *modernismo*, a painting movement influenced by the Parisian painters of the *fin de siècle* in Montmartre: Toulouse-Lautrec, Erik Satie and the Nabis. Picasso would always return to the bistro and to his friends there. Ramón Casas painted the immense mural of the cyclists on the left-hand wall as you enter Els Quatre Gats, portraying himself and the celebrated Père Romeu, the founder of the bistro. (For many years, the bicycle was replaced by an automobile, but now, in 2004, the bike is back.) Picasso had been introduced to the bistro in 1898 by Manuel Pallarés, who he had met at La Lonia, and who became his 'guide to Barcelona'. More importantly still, Pallarés came from the mountain village of Horta del Ebro, where Picasso went at his invitation and where his first Cubist paintings would be done, in the late 1890s: 'Everything I know I learnt in Pallarés' village'.[4]

Always, on his frequent return visits to Barcelona in the years to come, Picasso would follow the same programme. He would arrive at his studio at 11 am, go at noon to Els Quatre Gats, have lunch there with his many friends, enjoying the prolonged conversations, then return to his studio until it was time to go home, when he might stop off at various cafés in the Ramblas. Then at night he would go out again to meet friends. His pals were part of the avant-garde, exactly the opposite of the right-wing Catholic institution, of which Antoni Gaudí, visionary and architect of the Sagrada Familia and the Parque Güell, was the most celebrated representative. This was the period of a Catholic revival in Europe: in France, Joris-Karl Huysmans, eccentric author of the far-out novel about a super-sensitive aesthete, *Against the Grain*, and a describer of the Black Mass, returned to the Church in 1894 and became a Benedictine oblate. In Picasso, the Catholic and the violent anti-clerical traditions made their war and their peace.

The printed menu of the Els Quatre Gats restaurant, designed by Picasso in 1899.

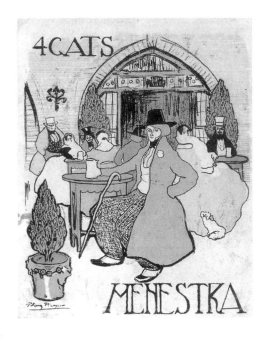

The menu cover for Els Quatre Gats, called *4 Gats: Menestra* (food) is the most celebrated piece of printed work that Picasso did in this period: it shows the Catalan Gothic exterior of the bistro, with a simplification and flattening of outline that are instantly appealing. A small bush planted at the lower left stops just at the height of the foregrounded patron's elegant and full trousers with their small-checked weave, while his top hat and his cocked left arm and his cane resting on the table just by his beer tankard held in his right hand mark the *cerveseria-taverna-hostal* (beer parlour-café-restaurant) as something high-modern styled and distinctive. The famous poet Rubén Darío visited the bistro in 1898 and was particularly impressed by the puppet show, the 'Putzinel-lis' put on by Miguel Utrillo (who with his lover, the French painter Suzanne Valadon, later frequented Le Lapin Agile in Montmartre, which became one of Picasso's favorite hangouts in Paris).

The first exhibition of an individual painter held at Els Quatre Gats had been that of Ramón Pichot, Picasso's closest Spanish friend, who would feed and lodge him in Barcelona on his return trips there from Paris. In the month following Picasso's exhibition, another one-man exhibition by Picasso's friend Carles Casagemas was held. As an exhibition space, the bistro was perfect, for just after viewing the paintings in the 'large room', or then viewing the marionette show (above which hung an informative sign about the importance of food and wine: 'l'home que be vulga viure, Bons aliments y molt riure'), the public – generally appreciative and in a good mood – could delight in the dishes. Among the chef's specialities were cod served on a board (*bacalao a la viscaina*) and Catalan-style tripe (*tripa a la catalana*), brought to the table by black-garbed waiters in white aprons and consumed among the columns and arches and modern-style paintings and sketches on each wall.

As well as a bistro, Els Quatre Gats was also a publisher of avant-garde journals, first *Quatre Gats*, in Catalan, and then, from 1899 to 1903, *Pel y Ploma*, in whose issue of June 1901 Picasso was featured, as he was in the succeeding Catalan journals of modernism like *Joventud* (1900–06). With a friend, the writer Francisco Asis de Soler, Picasso published his own art journal in Madrid, *Arte Joven*, in 1901. It was modelled on *Pel y Ploma*, and included a drawing of Picasso's, as well as pieces from the artists and writers whom the two editors had met in Madrid's place for a *tertulia*, the Café Madrid, and their Barcelona friends. It featured writings by Pio Baroja and Miguel de Unamuno, members of the celebrated 'generation of '98' – but it did not last long, only from March to June. Els Quatre Gats itself lasted from 1897 to 1903, in July, when many of the *modernista* painters left for Paris. But the Barcelona influence is clear in Picasso's 'Blue Period', when he remembered in particular the paintings of Rusiñol and Casas. Jacobus Sabartès – who was to become Picasso's right-hand man in Paris, overseeing his appoint-

ments, schedules, meetings with dealers, and just generally serving as bridge and bouncer, and whom he had known at Els Quatre Gats – presided over a series of literary evenings, which were the last events held there.

In October 1897 Picasso had returned to Madrid, where he completed in one day the exams for the Royal Academy of San Fernando, repeating his success from Barcelona. He again frequented the Prado and became ever more steeped in the Spanish tradition. But to see what was going on in contemporary art, you had to be in Paris, which occasioned his various trips or 'pilgrimages' there. Picasso first went to Paris in October 1900, at the age of 18, using the studio that his Catalan friend Isidro Nonell had just vacated. Immediately he began to mingle with the large Catalan community in the city, including Paco Durio (a friend of Gauguin), Ramon Pichot, Zuloaga, Ricardo Canals and the sculptor Manolo Hugué, all from Barcelona. At the Exposition Universelle then on show at the Grand Palais, Picasso's *Last Moments* (1899–1901; Musée Picasso, Barcelona), in conté crayon on paper in his *modernista* style, was on display; it had already been shown in Malaga in the summer of 1899 and at Els Quatre Gats in his February show of 1900. Even as a young painter, he was widely noticed by dealers and public.

In Paris, he met the Catalan Petrus Mañach, who was to be his dealer for some time. Mañach arranged exhibitions of Picasso's paintings at the Berthe Weill gallery, and actually shared his own small place at 130 boulevard Clichy with him; he also introduced him to Ambroise Vollard, who was to become Picasso's first gallery owner and close friend. It was through Vollard that Picasso encountered the work of Paul Gauguin, whose Synthesist style, together with that of Maurice Denis and Felix Vallotton, was to influence his work. Picasso returned to Barcelona in December 1900, but went to Paris again in the spring of 1901 and of 1902, on each occasion staying there for several months.

The tragic face of Picasso's *Self-Portrait* (Musée Picasso, Paris), with its heavy lips and melancholy eyes, dates from late 1901. This spirit persists in particular through his Harlequins, and marks with consistency his early paintings – and his life and art in many instances – appearing still in his ravaged *Self-Portrait* of 1972, with its shape and shading of a skull (Fuji Television Gallery, Tokyo, and Private Collection). Whether or not it started with his sister Conchita's death, it was intensified by the suicide of his Catalan friend Carles Casagemas on 17 February 1901. Casagemas had accompanied Picasso to Paris, but returned to Barcelona in despair, after his rejection by the half-Parisian, half-Spanish Germaine Gargallo, who had been and was to be Picasso's lover, and then the wife of Ramón Pichot. Picasso tried to cheer him up by listening with him in a café to singers of the *cante hondo*, a profoundly folk-loric form of lyricism, but to no avail. Casagemas returned again to Paris and killed himself after firing at Germaine and missing. In commemoration, Picasso painted *The Death of Casagemas* (Musée Picasso, Paris), with yellow stripes on the winding cloth. Apollinaire, who called himself Picasso's best friend, recorded Picasso's comment on the painting: 'If I began to paint in blue it is because Casagemas was on my mind.' Apollinaire continued: 'For a year Picasso lived this pitiful, sodden blue paint like the bottom of an abyss.'[5] A later double portrait of the painter with Germaine Pichot has them both leaning on a table, grim. A painting of 1903, *La Vie* (Cleveland Museum of Art), pictures a nude man, resembling Casagemas, with a nude woman clinging to him, across from a woman holding a child, in an artist's studio. Originally, the man had the face of Picasso – part of the strength of his works, early and late, comes from his self-identification with the figures he paints, tinted with guilt in this case. He overpainted *Last Moments* with *La Vie* of 1903, as Jack Flam explains, painting out the deathbed scene and 'conflating on a single canvas his feelings of responsibility for the deaths of Conchita and Casagemas'.[6]

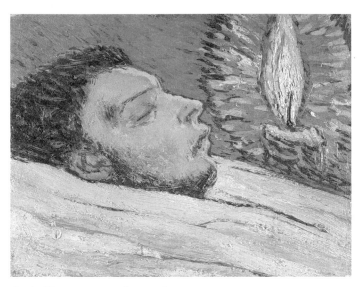

Death of Casagemas, 1901, oil on wood.

The blue spread into his 'Blue Period' (generally dated from the spring of 1901, in Paris, to 1903 or 1904). In this, he shared Isidro Nonell's extreme ('realist') point of view on the tragic, the misery in the old Gothic quarter of Barcelona, the hungry prostitutes and the mothers with babies: this mournful vision of things was begun in Paris. A blind man leans over a plate (*The Blind Man's Meal*, 1903); destitute figures prop themselves up with difficulty on café tables; an *Old Guitarist* (Art Institute of Chicago), painted in Barcelona in 1903, slumps over his instrument with his legs crossed awkwardly, in clear despair. About his Blue Period, Picasso said: 'I didn't plan to paint symbols. I simply painted the images which arose before my eyes.'[7]

His fellow Catalan, Sebastià Junyet Vidal, with whom Picasso had journeyed to Paris in October 1902, explained that Picasso was capable of 'the most powerful lamentations, the subtlest dreams, the most intimate songs, and the completeness of a serious soul', whose

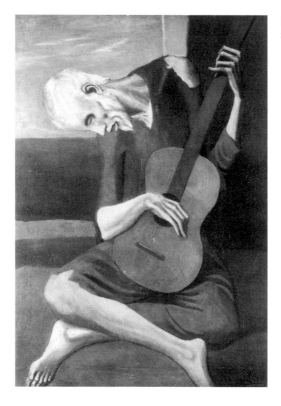

The Old Guitarist, 1903, oil on canvas.

work illustrated 'the psychological tension of themes and things'.[8] This was his protection against his too easy virtuosity and brilliance, a trap warned of by such critics as Félicien Fagus: there was danger in 'this impetuosity which could lead him to a facile virtuosity, a too easy success'.[9] André Billy summed up Picasso's character, along with the mystic and the sensitive parts, as 'Malice, ingenuity, envy, melancholy, irony, gentleness, kindness, cruelty, salaciousness, anything you want except innocence, simplicity, true gaiety'.[10]

From his first explorations in sculpture in Barcelona (*Seated Woman* of 1899) to his later *Head of a Picador* of 1903 (the subject taken up again in his *Picador with a Broken Nose* of 1970, a painting

in the Rienzo Gallery) to the renewal in 1928 of his friendship with the Catalan sculptor Julio Gonzalez, in whose studio he spent a good deal of time, a kind of monumental character shaped Picasso's work. His classic figures often seem outsized, as does his imagination: some of them are based on Salomon Reinach's *Répertoire de la statuaire grecque et romaine* (*Guidebook to Antique Sculpture*).[11] He frequently invoked the Spanish classics, not just the Graeco-Roman ones. Take his portrait of 1903 of the one-eyed *entremetteuse* or go-between *La Celestina* (Musée Picasso, Paris), from the play by Fernando de Rojas. This last of the paintings called his 'parable paintings' was completed in his Barcelona studio on the calle Riera de San Juan, which he had formerly shared with Casagemas. All his life the allegory of the blind stayed with him, the other side of what John Richardson refers to as the *mirada fuerte*, his staring, unforgiving gaze.

In 1902, after a breakdown in his relations with Mañach, he returned to his beloved Barcelona, and stayed there until 1904, near the Rambla del Centro. Of all he did and saw in Barcelona, it is perhaps the Museu de Arte Catalunya that was the most formative influence on him. He knew it when he was young, of course, and then revisited it often, to see the early frescos of Romanesque art. So many images made a strong impression on him, among them those of the twelfth-century fresco of the *Virgin and St John the Evangelist*, and in particular the *Dying Bull* and the *Crucifixion*: they were linked in his mind, through the pagan sacrifice in the bullring, and the sacrificial Christ.[12] The bullfight and the sun beating down, the cruelty and the Mithraic ritual, would reappear in the iconic and terrifying *Guernica* of 1937 (Prado, Madrid), with its harsh light, light bulbs and bull. The entire Spanish tradition weighed on Picasso's mind and work.[13]

Clearly, the three Spanish painters referred to most often by Picasso were Goya, Velázquez and El Greco. In Robert Rosenblum's essay, concerning not just 'The Spanishness of Picasso's Still Lifes'[14]

but his entire connection to the tradition, he points out that when the painter was at the academy in Madrid, from October 1897 to June 1898, he and a friend would spend all their time at the Prado, eight hours a day, studying and copying, and then three hours each night to draw from nude models at the Circulo de Bellas Artes.[15]

It was not until the early part of the twentieth century that the mannerisms of El Greco – which were so influential on Picasso's *Les Demoiselles d'Avignon* of 1907 and other works – were accepted in Spain by critics and public. Velázquez was easier to admire, for both, and became increasingly revered in Spanish culture of this period, from the 1890s. And Goya, of course, had always been revered by that culture, so that Miguel Utrillo's calling Picasso 'le petit Goya' was well accepted by the sometimes prickly painter, who had absolutely no uncertainty about his Spanishness. As he said of the movement with which he is so often identified, 'Cubism is Spanish in origin, and it was I who invented Cubism.' These three old masters were seen as being on the margins of the classical, as being in their way 'counter-classical'. It is clear that Picasso studied the painting now called *The Apocalypse of El Greco* (formerly *The Opening of the Seventh Seal*), and that during the painting of *Guernica* he studied bullfight prints of Goya.

In Rosenblum's view, because of the revival of nationalism, after the deceptions of globalism, Picasso's 'identity as a Spanish rather than as a French or universal artist has become ever more apparent in recent decades'. He points out how

> the holiest Spanish trinity of great masters – El Greco, Velázquez and Goya – constantly haunted his figural inventions, whether he dealt with the suicide of a Catalan friend, Carles Casagemas; the hallucinatory vision of a brothel parlor in Barcelona's red-light district; the bombing of the Basque capital, Guernica; or the corpses photographed in a Nazi concentration camp.[16]

And, in particular, how the Spanish still-life tradition, from Sánchez Copán to Luis Meléndez, picks out the 'obdurate individuality' of each object, to which no particular hierarchical order is assigned, over against the harmonious Chardin sort of French still-life, with which Georges Braque is associated. Juan Gris he associates more with Zurbarán's 'somber colors and lucid austerity'. The anonymous twelfth-century fresco of *St John the Evangelist* in the Museu Nacional d'Art de Catalunya, and the painting of the *Virgin and St John*, have an impact on Picasso's *Two Sisters*. The classical origins of Catalan culture and that of the Mediterranean people are everywhere visible: in the *noucentisme* of Puvis de Chavannes, Renoir, Cézanne and Maillol, and in the French Catalonian writer on the Baroque, Eugeni d'Ors.

Very Spanish too are the 'chromatic extremes' of Picasso's work: from the sombre palette with its greys and browns and blacks, to the brilliance of fiesta colours, with a particular stress on Spanish yellows and reds. The *corridas* of Céret and the nearby Nîmes left their traces in his work, as did the medieval Catalan frescos, with their strong outlines and colours, and their unforgettable emotive power. High on a hill overlooking Barcelona, the Museu Nacional d'Art de Catalunya seems to contain the very essence of Spanish tradition. After the tragic Madrid train bombing of March 2004, it was here – quite naturally – that a group of young musicians chose to hold their memorial service for the dead, while in the main square of Barcelona below a large circle of vigil lamps kept watch and there was a constant drumming day and night, like a heart beating in loud grief. Picasso's own emotional intensity in its tragic power and its convulsive beauty (I am using the Surrealist term on purpose), is, more than anything, deeply Spanish, fundamentally Catalonian. His is a Spanish identity.

3

Paris: The Bateau-Lavoir

You are at the door of the century. You have the key to the door in
your hands.

Vicente Huidobro to Picasso[1]

This is, during the years around 1904–5, Picasso's 'Rose Period'.
It is not only the rose hue that marks the epoch in his work, but
the change from the miserabilism of the 'Blue Period', whose fig-
ures are, says Meyer Schapiro, entangled 'introverted, medieval
types . . . homeless, impoverished . . . in postures of self-con-
straint, of self-enclosure, turning away from the world either
through blindness, or reddened eyes, or through the lowering
and shutting of the eyes while the figure listens rather than looks'
in a sparse Environment'.[2] The 'Rose Period' works often relate to
the circus, to Harlequin, to Pierrot, and to the circus acrobats or
Saltimbanques. In 1905, at the Galeries Serrurier, on the boule-
vard Haussmann – that boulevard famous now for having so long
housed Marcel Proust – Picasso exhibited , from 25 February to 6
March, his first 'Rose Period' paintings, including eight
Saltimbanques. To be sure, the show was not long (he shared it
with Albert Trachsel and Auguste Gérardin, far less well known
now than our protagonist), but it had an effect. The catalogue
preface was written by Charles Morice, well known at that time,
and the beloved Cubist poet and essayist Guillaume Apollinaire –
Picasso's lifelong companion of the mind – reviewed the exhibi-

tion for both *La Revue immoraliste*, in April, and *La Plume*, in May; in the latter, five of Picasso's works were reproduced.

His dealer Vollard was delighted with the work, cast his *Jester* in bronze, and printed a series of Saltimbanque drypoints and etchings. Another dealer, Sagot, introduced Picasso to Leo and Gertrude Stein, and thereby hangs a well-known tale, of their acquisitions of Picasso, and of his close association with Gertrude, whose portrait he began in 1906. This was also to be a year in which the rose hue of his work gradually gave way to other hues; in which Gertrude Stein introduced him to the older painter Henri Matisse, and in which he met André Derain.

But this period is marked no less hugely by Picasso's friendships of these years with several other painters. It all started in the Bateau-Lavoir, or the Laundry Boat, so called for its very odd shape. Once, walking with a friend by that ramshackle building on the rue, Picasso is said to have exclaimed: 'That is the only place where I was ever happy!'[3] As I now re-examine Picasso's early years in Paris, during and just before the Bateau-Lavoir experience, it seems to me marked above all by his relation to the poet Max Jacob. There was also, to be sure, the extrovert and genial Guillaume Apollinaire, and there was André Salmon, a less colourful figure, and there was also Fernande Olivier – but I will start with Max. 'No one ever got bored with Max.'[4]

He had been an art critic, under the name of Leon David, during the years 1898–1900, at the *Moniteur des Arts*. And when he met Picasso, at Vollard's gallery, organized by the Catalan Petrus Mañach, the painter was only 18 and spoke not a word of French – nor did Max speak any Spanish or Catalan. The description of Vollard and his gallery given by Patrick O'Brian is colourful. First of all,

> it did not look like a picture gallery . . . Canvases turned to the wall, in a corner a small pile of big and little canvases thrown

The poet and painter Max Jacob, c. 1936.

pell-mell on top of one another, in the centre of the room stood a huge dark man glooming. This was Vollard cheerful. When he was really cheerless he put his huge frame against the glass door that led to the street, his arms above his head, his hands on each upper corner of the portal and gloomed darkly into the street. Nobody thought then of trying to come in.[5]

A perfect setting for Picasso's future paintings.

Picasso returned to Barcelona in December 1900 with the ill-fated Casagemas, but he couldn't wait to return to Paris, which he did the following spring. The moment he was set up at 130 boulevard de Clichy, he instantly began to paint with a frenzy. He and Max Jacob saw each other every day, and every day Max would hum Beethoven

or some other composer whose works he loved, and would read poetry aloud in his magnificent voice. What a beginning to Picasso's Paris experience – the Paris that Max knew so well! Of this period, Max wrote in his memoirs: 'We were lost children, both of us.'[6]

In January 1902 Picasso returned again to Barcelona, where he wrote to his dear friend with his inimitable spelling and French, giving even more warmth to the affection: 'Mon cher Max il fait lontan que ye ne vous ecrit pas – se pas que ye ne me rapelle pas de toi mai ye trabaille bocoup se pour ça que ye ne te ecrit' (more or less: 'Dear Max, I haven't written to you for a long time – it isn't that I don't remember you but I am working a lot and that's why I haven't written to you').[7] Who could resist?

Picasso came back to Paris in October 1902 to live in the Hôtel Champollion, and then the Hôtel du Maroc, where he shared quarters with a sculptor named Sisket, who left plaster all over the floor. Picasso was so discouraged by the messy surroundings and the impossibility of selling his paintings that he once threw a painting that the dealer Berthe Weill had refused to buy from him in the sewer. Then Max Jacob took him into his own room, writing about this in his 'Chronique des temps héroïques'.[8] So there was Picasso, in 1903, living in Max's room at 150 boulevard Voltaire, on the fifth floor, painting all night and sleeping in their one bed in the daytime, while Max was working in a store called Paris-France at 137 boulevard Voltaire. Both were penniless. They were sustained mostly by such noble texts as Alfred de Vigny's *Moïse* (1822), in which Moses laments his loneliness because of his power, and addresses his God in extreme unhappiness:

> *Vous m'avez fait vieillir puissant et solitaire*
> *Laissez-moi m'endormir du sommeil de la terre!*

> You've made me age powerful and lonely –
> Let me rest in the sleep of the earth![9]

Let me rest in the sleep of the earth . . . Both Picasso and Max embraced the idea of suicide, and felt disappointment with all those about them. So Picasso wrote to Max from Barcelona on 1 May 1903 that he was doing well not to be seeing anyone, since people are so unlovable:

toi fait bien de no frecuenter persone les homes il son tres mechantes
et tres betes ye ne les aime pas en persone
Tou me crirai suvent nes pas?
Adieu mon vieux Max ye te ambrase
Ton frere [sic] *Picasso*

you do well to not frequent anyone men are very mean and
stupid I don't love them in person
You will write me often, won't you?
Farewell my old Max I embrace you
Your brother Picasso[10]

Max's mood was not a good one in those days, since, despite his homosexuality, he was in love (with a woman, presumably for the only time in his life) with Cecile Acker, whose husband worked at the same store: 'La seule passion violente de ma vie' ('the only violent passion in my life').[11] This frustrated passion is reflected in his *Saint Matorel*, where Mlle Léonie is the mistress of Victor Matorel.

Things came to no good end. Max was so poor that he moved in to live with his brother Jacques at 33 boulevard Barbès, and sold his books to make money. Nevertheless, there was richness within: 'Ami cher à mon coeur, sache que j'ai de la literie' ('Friend dear to my heart, please know that I have bedding: two comforters, four pillows, and two mattresses, so you can come to stay'), he wrote to Picasso.[12] Later, as André Salmon pointed out, when Picasso was installed at the Bateau-Lavoir, when he would have gladly returned the welcome and taken in Max, the latter knew that 'The hospit-

ality of his dear Pablo would have weighed him down. Max Jacob knew he would have been paralyzed by the permanent invention of Picasso.'[13]

Max's love for Picasso was visible in everything he did and tried: Pablo shaved off his moustache? So did Max. 'I wrote verse because Picasso had found I had talent and I believed in him more than in myself.'[14] Apollinaire had the same thoughts about Picasso's opinion: 'Even when he could hardly speak French, he could instantly judge the beauty of a poem . . . Picasso laughed and his laughter was our goal.'[15]

Once, says Max, Picasso came through the hall of the Bateau-Lavoir at two in the morning 'and shouted through my door, "what are you doing, Max?" "I'm working at my style". Picasso replied: "there is no style!" And then he left.'[16] Picasso would often say: 'I am probably a painter without style . . . I shift about too much, I move too often. You see me here, and yet I've already changed. I'm already elsewhere. I never stay in one place and that's why I have no style.'[17]

Max and Pablo dedicated poems to each other, drew together, and even shared a notebook: Picasso made a brief trip to Schoorl, north of Amsterdam, with the money that Max had borrowed from the concièrge, giving him a little notebook that he had already written in, in which Pablo then drew. Having shared a bed before, they now shared a notebook – and a top hat. For one duel with a journalist, interesting only in the following anecdote, Picasso lent Max Jacob his top hat, but when Max removed it, there was PICASSO writ large inside its crown. That must have been the way it felt in general to Max Jacob: Picasso was writ large.

In the Bateau-Lavoir, everything was shared by the 'bande à Picasso', all creators: writers and painters, and everyone was poor. There were actually only four of them: the poet and painter Max Jacob, André Salmon the writer and opium addict, around whom a crowd was always gathered, and the great Guillaume Apollinaire,

poet and exalter of Cubism. Pierre Reverdy and Juan Gris, two more great Cubists, came later to the Bateau-Lavoir. Picasso remembered, as did Max Jacob, the first meeting of the two of them: they conversed all night in sign language, since neither spoke the other's language. They both remembered meeting Apollinaire at Austin's Fox, a bar near the train station of Saint-Lazare. Max Jacob remembers him as carrying 'a thousand little books . . . Apollinaire stretched out his hand and in that moment there began a triple friendship that lasted until Apollinaire's death'.[18] They all spent their evenings 'devouring bread and sardines at a table covered with newspaper with one napkin for everybody, in a studio smelling of turpentine and dominated by *Les Demoiselles d'Avignon* or whatever was hanging on the wall or standing against it'.[19]

At this point, the world-famous-painting-to-be was *The Bordello* (*Medical Student, Sailor and Five Nudes in a Bordello*, composition study of 1907 for *Les Demoiselles d'Avignon*, now in the Offentliche Kunstsammlung, Basle) – and the shock of it was never to die down, nor has it yet. It may seem strange to us now that the Steins did not instantly desire to purchase the painting, having and continuing to have such a passion for Picasso's work – and for him, in the case of Gertrude. In 1907 they even rented him another studio in the Bateau-Lavoir, for the extra space it afforded him, advanced him money, and bought his work. But something about the canvas, compelling as it was, led them not to want it. As Gelett Burgess said of it, when he was taken to Picasso's studio to see it, 'Monstrous, monolithic women, creatures like Alaskan totem poles, hacked out of solid, brutal colors, frightening, appalling!'[20]

In any case, Max Jacob had, as John Richardson puts it, fallen in love with Picasso in 1901, and never changed. There was no way that Picasso could return Max's 'overheated feelings, but in his cannibalistic way he lived off them'.[21] As Max put it, in those years, 'We all lived badly. The most marvellous thing is that we managed all the same to live.'[22] They all ate lunch in Picasso's studio, at

noon, even when he was in what André Salmon called a 'blue universe'. As Picasso later recounted to Hélène Parmelin: 'We had no other preoccupation but what we were doing and . . . saw nobody but each other: Apollinaire, Max Jacob, Salmon . . . Think of it, what an aristocracy!'[23] Indeed. Max was poor and loving, André Salmon was addicted and clever, Apollinaire was Apollinaire and Picasso was Picasso. They were not so dissimilar, the poet of Cubism and its painter. The 'subversive sexuality' of Apollinaire's pornographic text *Les Onze mille verges* ('The eleven thousand penises') has a great deal in common with the savage presentation of *Les Demoiselles d'Avignon*.[24]

It was in the Bateau-Lavoir, in 1904, that Picasso met Fernande Olivier, 'la belle Fernande', who lived there also. He blocked her way, as she was getting water one day in the basement, stretching out his arms and offering her the cat he was holding, so she couldn't get by. This was a perfect tease, and, unsurprisingly, things transpired and went on. In the long run, of course, as we know in retrospect, Fernande was to be sacrificed to art, 'to which all the women in his life would ultimately be sacrificed'.[25]

On Picasso's door, there had always been a notice: *Rendez-vous des poètes*, and they had come: Max Jacob, Apollinaire, Salmon, even Pierre Reverdy, a later arrival. But in fact, after a time, the painters André Derain and Georges Braque slowly changed their primary allegiance from Matisse to Picasso. Picasso had met Matisse through Gertrude Stein, and had been startled, overcome in fact, by Matisse's *Le Bonheur de vivre* (1905–6; Barnes Foundation, Lincoln University, Merion, PA), shown at the Salon des Indépendants. From then on, his most intense reaction in disbelief at the inventiveness of Matisse was to be one of the primary components of his own creation. His own *The Death of Harlequin* (1906; National Gallery of Art, Washington, DC) in his 'Rose Period', but strangely resembling his former *Death of Casagemas*, shows the opposite mood from *Le Bonheur de vivre*, and predicts what Rosenblum and others would

refer to as 'the moral and tragic nature of much of Picasso's later work'.[26]

Yet the freedom of figuration in Matisse's work, as well as the primitive influences upon it, were essential to Picasso's development. As Jack Flam and others have pointed out so convincingly, every time Matisse painted something as remarkable as *Le Bonheur de vivre*, Picasso would respond with a work of his own – as, later, his *Joy of Living (Joie de Vivre)* of 1946 (Musée Picasso, Antibes). He would absorb the leap of imagination, and go on from there – the reverse situation was no less true. It was a working relationship, which we might see as a mode of mutual celebration, rather than imitation. The differences are as intense as the reactions: as Flam points out, Matisse painted in the day, Picasso at night, and thereupon hangs much.

Yet a further detail about that painting of joy and abandon is of sustained fascination for our story. On his way to and from the new studio he had rented in which to paint *Le Bonheur de Vivre*, Matisse passed by a window of a shop in the rue de Rennes, in which African sculpture was exhibited. This was early in 1906; in March, Derain sent him from London drawings of the African and Oceanic art he was seeing in the British Museum, and that summer Matisse completed an African-influenced sculpture, a *Standing Nude*. 'Compared to European sculpture, which always took its point of departure from musculature and started from the description of the object, these Negro statues were made in terms of their material, according to invented planes and proportions.'[27] Matisse purchased a small Congolese carving and took it to Gertrude Stein's, to show her, at which point Picasso came by. 'That was when Picasso became aware of African sculpture.' Matisse's *Blue Nude* (1907; Baltimore Museum of Art), shown at the Salon des Indépendants the following year, in what Flam calls its 'aggressive ugliness' and deliberate awkwardness, was no less influenced by African art and its 'primitive intensity and violence', and had a no less powerful effect on Picasso.[28] That spring

of 1907 Picasso visited the Trocadéro's ethnographic museum, and was overcome by the African masks, as magical things.

> The Negroes' sculptures were intercessors, I've known the French word ever since. Against everything; against unknown, threatening spirits. I kept looking at the fetishes. I understood: I too am against everything . . . If we give form to the spirits, we become independent of them . . . *Les Demoiselles d'Avignon* must have come to me that day . . . because it was my first canvas of exorcism – yes, absolutely![29]

The *Demoiselles* hung on the wall of Picasso's studio, and his friends gathered for lunch directly in front of it, in the various transmogrifications of this 'philosophical brothel', as it was then called. In the Bateau-Lavoir, friends abounded, and Picasso abounded in friends. At this point, the gathering and living and working place had become one giant *tertulia*, and the fabled 'rendez-vous des poètes' was swiftly turning into a 'rendez-vous des peintres'. During the time that Picasso lived there, apart from Max Jacob and André Salmon, there were also Kees Van Dongen, Maurice Vlaminck, Georges Brque, Juan Gris and Amadeo Modigliani, as well as André Derain. Derain had anticipated the appeal of African art, and was one of Max Jacob's main causes of jealousy; Max always remained somewhat jealous of Derain, for his relation to Picasso, since the friendship between them intensified. It was Derain who had urged Picasso to visit the Ethnographical Museum, which occasioned Picasso's crucial confrontation with African art, about which he had his 'revelation', realizing that it was not just art but exorcism. It is an interesting sidelight on the Picasso / Derain relationship that Alice Gery, who would in the course of time marry Derain, had been Picasso's mistress, and that it was Picasso who had arranged for her to meet Derain at a lunch he organized. (Picasso, although in a less flagrant mode than the *entremetteuse* La

Celestina, was fond of arranging things for people, including their futures.) In the subsequent years, even after his incredibly close work with Braque, Picasso would see as much of Derain as of Braque, admiring him for his eclecticism, probably finding it much like his own. And eventually he would acquire Derain's *Girl with a Shawl*, now exhibited in the Musée Picasso in his collection.[30] In a sidelight as peculiar as it is fascinating, Apollinaire would eventually claim, for some unknown reason, that Derain invented Cubism, a claim both bizarre and untrue, and hurtful to its real inventor, Picasso, and his friend Georges Braque.

The American collectors Leo and Gertrude Stein – she the celebrated writer and pioneering lesbian, who had studied medicine at Harvard before moving to France with her brother – are the subject of Brenda Wineapple's essential *Sister Brother.* Her documentation of the reception of the Steins in Paris includes Jacques-Emile Blanche's repeating of gossip spread by Raymond Duncan, the dancer Isadora's brother:

> They, immigrants from Austria, had first collected copper objects in everyday use and then sold things so as to collect things of greater value. Buying and making collections of objects which catch people's fancy is a quality that the Jewish race has brought to the pitch of genius. . . Indeed, works of art become a banker's security.[31]

Sister and brother had an eventual falling-out, and Gertrude's lover Alice B. Toklas was to replace Leo in the Stein establishment on the rue de Fleurus, where Ernest Hemingway and many other writers came so often to visit and look at the art. In the years before their split, Leo and Gertrude had acquired several Picassos: Gertrude bought *Young Girl with a Fan* (1905; National Gallery of Art, Washington, DC) and *Young Girl with a Basket of Flowers*, and Leo *The Acrobat's Family with a Monkey (an Ape)* (1905;

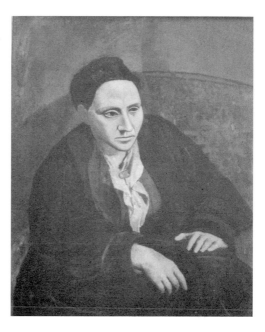

Gertrude Stein (Homage to Gertrude), 1906, oil on canvas.

Konstmuseum, Göteborg). They were later to acquire *Three Women* (1908; Hermitage, St Petersburg), a sequel to the *Demoiselles*, to compensate, at least psychologically, for Sarah and Michael Stein's consideration of and presentation of Matisse as the *chef d'école*.[32]

Since Gertrude's French was very weak, she could not always follow a French conversation, and, in any case, Picasso's French was not of the ordinary sort. There was clearly a 'mutual fascination' between them. She sat on a large armchair, almost broken down, in the studio of the Bateau-Lavoir, while Picasso sat studying her, on a small kitchen chair, sitting up close to his canvas. After some 80 sittings, he wiped out her face, saying he couldn't see it, and then, later, filled it in with the massive conviction we now know (Metropolitan Museum of Art, New York). This celebrated portrait of 1906 is often compared to Ingres's portrait of *Louis-François Bertin* (1932) in the Louvre, that 'ungainly, informal and confrontational' picture of the hunk of a man

squarely facing the onlooker.[33] Stein acknowledged the wisdom of his action: 'I was and I still am satisfied with my portrait; for me, it is I, and it is the only reproduction of me which is always I, for me.'[34]

The Steins occasionally celebrated their version of a *vernissage*, which was, of course, a mockery of the institutional receptions and varnishing, so Picasso was particularly and understandably irritated when the Steins varnished two of his paintings they had acquired. Gertrude Stein was convinced she knew more than almost anyone about Picasso's painting, and wrote at length about it. Some of her thoughts in the form of notes follow here, beginning with an amusing convergence of her own writing with the creations of the two greatest painters of her time:

> Matisse, Pablo and I do not do ours with either brains or character we have all enough of both to do our job but our initiative comes from within a propulsion which we don't control, or create.

> Pablo's instinct is right, he does not wish to slow himself but to concentrate himself.[35]

> Pablo & Matisse have a maleness that belongs to genius. Moi aussi perhaps.[36]

In the third part of her work of 1938 called just *Picasso*, she made a claim that would of course be extremely irritating to Georges Braque. She had collected Picasso and not Braque, quite possibly a consideration for this quite peculiar and limited point of view:

> Painting in the nineteenth century was only done in France and by Frenchmen, apart from that, painting did not exist, in the twentieth century it was done in France but by Spaniards . . . there was a world ready for Picasso who had in him not only all Spanish painting but Spanish cubism which is the daily life of Spain.[37]

This outlandish statement is transparent in its slant towards her own preferences, and yet not altogether without foundation. Back in Paris in 1904, she says, Picasso was 'again seduced by France', what with seeing Apollinaire and Max Jacob and André Salmon constantly, and forgot Spanish sadness, 'living in the gaiety of things seen, the gaiety of French sentimentality'. He was above all living, she says, in the poetry of his friends.[38]

Picasso's frequenting the Medrano Circus once a week had to do with his voluntary refusal of 'the gentle poetry of France' for the excitement of the circus life and figures.[39] And then, 'after the harlequin period, being Spanish commenced again to be active inside in him and I being an American, and in a kind of way America and Spain have something in common, perhaps for all these reasons he wished me to pose for him'. After all, she concludes:

the twentieth century has a splendor which is its own and Picasso is of this century, he has that strange quality of an earth that one has never seen and of things destroyed as they have never been destroyed. So then Picasso has his splendor. Yes. Thank you [40]

I love the 'yes'. Stein was often in the 'yes' mode. It is interesting to note that Picasso's later *Homage a Gertude* [*sic*] (1909; Private Collection) was to be seen on the ceiling, viewed from below: there is something cheerful and upbeat about that.

There was often gaiety in these years. In Montmartre, Frédé opened the bistro called Le Lapin Agile, where, from the beginning, Picasso's merry band would go often to listen to Harry Baur and Dullin recite the poems of Ronsard or Villon, or to hear Francis Carco singing light café tunes. On the walls were paintings by Maurice Utrillo, by his mother Suzanne Valadon, and also a painting by Picasso, called *Le Lapin agile* (1905; Private Collection), done in the yellows and reds of the period that historians compare

to the work of Toulouse-Lautrec. The painting shows Picasso disguised as a Harlequin, Germaine Pichot and Frédé sitting on a barrel playing the guitar . . . and a tame bird.

Picasso would be, as his long life went on and on, more in disguise. But with Max, in those grand early days, he had been disguiseless and guileless. As for recounting his relation with Picasso or speaking of it, Max found that hard. As he wrote to Jacques Doucet in 1917, at Doucet's request to him to write on his painter friend, 'I haven't written anything on Picasso. He hates people to write about him.' But he did manage a few autobiographical reflections for *Vanity Fair* in 1923, in a piece entitled: 'The early days of Pablo Picasso: a memoir of the celebrated modernist painter by a friend and contemporary', and then, finally, in *Cahiers d'art*: 'Souvenirs sur Picasso contés par Max Jacob'.[41]

In those grand young years there were so many major happenings that they could scarcely be recounted. In their spirit, 'la bande à Picasso' remained grouped around that place in which they had all been so poor and so happy, the Bateau-Lavoir. Years later, in his bourgeois apartment on the rue La Boétie, when he felt free nowhere but in his studio on an upper floor, Picasso allowed up in that space only friends 'who had gone, or were worthy to have gone, to rue Ravignan'.[42]

4

Les Demoiselles d'Avignon and the Beginnings of Cubism

Would I be so pathetic as to seek inspiration . . . in a reality as literal . . .
as a specific brothel in a specific city on a specific street?
Picasso to Robert Otero[1]

In the winter of 1906–7, Picasso began work on *Les Demoiselles d'Avignon* (Museum of Modern Art, New York). It was because of this world-famous painting that John Richardson qualified Picasso as 'The Painter of Modern Life', an opinion now generally shared. The title of the painting was not one that Picasso would have chosen; it was given to it by André Salmon for its exhibition at the Salon d'Antin in 1916. Salmon named it after a famous brothel in the carrer d'Avinyo in Barcelona (for its clear reference to harem paintings, with the naked females), with an ironic reference to Max Jacob's grandmother, from Avignon, where his mother had also lived.

As it hung in Picasso's studio, called the 'Philosophical Brothel', or, variously, *Le Bordel d'Avignon*, it was first a watercolour of a brothel composition, with seven figures: five nude women, a sailor and a medical student, both of whom disappeared in the later version, the student replaced by a nude woman lifting a curtain. Picasso always denied the impact of African sculpture and the Iberian tradition on this work (as in two sculptured heads that Apollinaire's secretary Géry Pieret had stolen from the Louvre), but the two faces on the figures at the right of the completed canvas clearly reflect

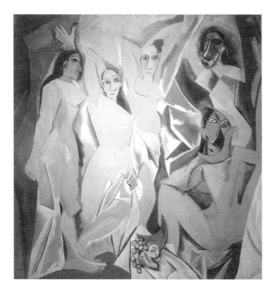

Les Demoiselles d'Avignon, 1907, oil on canvas.

those influences. And, subsequently, Picasso painted what are known as his 'African' pictures: *Nude with Drapery* and *Nude with Raised Arms*. Robert Hughes points out the signal importance of violence in African culture and art, and in the *Demoiselles*: 'With its hacked contours, staring interrogatory eyes, and general feeling of instability . . . No painting ever looked more convulsive. None signalled a fast change in the history of art. Yet it was anchored in tradition' – Cézanne's *Bathers*, the whole Spanish heritage, with the caryatid-like standing nudes, and the 'El Greco twist' of making the space around the figures as solid as draperies, as in El Greco's *Visitation* of 1610–14.[2] Rosenblum sees the reflection of 'the whole Renaissance tradition of the monumental nude, whether the noble structural order of Poussin and Raphael or – in the extraordinary anatom-ical compression of the two central figures – the anguish of Michelangelo's slaves', while the nudes at the left 'evoke the Venuses and Victories of the Hellenistic world, and then, cruder and more distant, the squat, sharp-planed figures of the pagan art of Iberia'.[3]

This was, said André Salmon in 1920, 'the ever-glowing crater from which the fire of contemporary art erupted'.[4] And Roland Penrose adds, that as the five prostitutes confront the spectator, the perspectival system in play since the Renaissance is overturned, and everything is seen from different angles. Instead of Manet's single stare of *Olympia*, we have five confrontations.[5]

Picasso was irritated by *Les Demoiselles d'Avignon* as a euphemism for the brothel, as in the first title of the painting, and insisted that it was an invented story, since this was in no way the kind of establishment to be found on the carrer d'Avinho, actually a 'respectable street . . . My characters are imaginary characters', he said.[6] But he had, after all, originally called it 'mon bordel'; the anecdotal sticks, and both Avignons cling to the painting. In fact, Avignon was to play a major role in Picasso's life and death. For the name now recalls the city in which Braque and Picasso painted together for the last time and which hosted Picasso's exhibition of 1970, and the last and glorious show he planned, in 1973.

The year 1907 marked also the Ingres-like and superbly faithful portrait of *Max Jacob* (Museum Ludwig, Cologne), which captures the dignity of Picasso's oldest Parisian friend. In October Apollinaire brought Georges Braque to Picasso's studio in the Bateau-Lavoir, and thus began the friendship that was also Cubism. This was the year, too, of the large Cézanne retrospective at the Salon d'Automne – that painter so massively important to Picasso and Braque. As Picasso said in his conversations with Brassai, 'Cézanne was my one and only master. It was the same with all of us – he was like our father. It was he who protected us.'[7] And Cézanne's *Five Bathers* (1890–91; Hermitage, St Petersburg) stand quite clearly behind these *Demoiselles*.

Both in Picasso's life and in his legend, the *Demoiselles* occupy a mind-boggling place, fully deserving of a chapter unto itself. The studies for this painting occupied Picasso for a long time indeed. It

was in front of some sketches that his friends in the Bateau-Lavoir gathered at noon for lunch. In its various metamorphoses, the painting has occupied art historians and critics with the same obsessive hold as it did the painter, who had become a recluse, huddled in his overcoat, obsessed, during his incubation of the painting in his sketchbooks, which prove that he was already working on the original painting in 1906.

If, in the beginning, a brothel in Barcelona had provided the original inspiration for *Les Demoiselles d'Avignon*, Picasso had equally been drawn to Degas' monotypes of prostitutes. In the spring of 1907 he did a study of a nude with raised arms, and sketches of hands sketched in, from the back. Of one of his *Nudes with Raised Arms* (1907; Private Collection) – which always reminds me of the way that Gauguin at the end of his life transformed the man plucking fruit in the centre of his immense painting *Where Do We Come From?* (1898; Guggenheim Museum, New York) to a woman simply raising her arms in a kind of invocation – Meyer Schapiro points out the 'spontaneous, purposive energy of shaping' and the 'aspect of savagery, of intense, wild expression'.[8] Picasso saw Matisse's *Blue Nude* (purchased by the Steins) and Derain's *Bathers* at the Salon des Indépendants of 1907. And, in fact, the second figure from the left, sometimes called the 'Nu à la draperie' or, formerly, 'La Danse aux voiles', like a sort of Salome or Loie Fuller, Picasso called his 'nu couché', in reference to Matisse's *Blue Nude*.

At one point in 1907, Picasso bought two Iberian sculptured heads from Géry Pieret, Apollinaire's secretary, who had stolen them from the Louvre. Always highly superstitious, he remained 'convinced that people's magic and strength rubbed off on things they had wrought or cherished, worn or used. Hence the compulsion not just to handle these numinous relics but to wrest them from the jaws of officialdom.'[9] This kind of primitive belief is an essential part of the painting's unique strength. The accounts of the stealing have their own fascination: both Picasso and Apollinaire

haunted by the heads, the arrest and temporary jailing of Apollinaire for the raids on the Louvre, taxi chases, newspaper accounts, and so on.

No less mesmerising is Picasso's account, to André Malraux, of his visit, around the same time as the affair of the statues, to the Ethnographical Museum at the Trocadéro (now the Musée de l'Homme). Derain had suggested he go there, and Vlaminck looked with him at the masks. There could be no more perfect listener than Malraux, given his superstitious instincts, his attitude towards the history of art as a concretion of past incidents and mythical inspiration, and his attachment to certain objects as the containers of ancient history to which a definite aura would always cling. When Picasso saw the African masks as 'intercessors, mediators', fitting in with his own oppositional spirit of against-ness, so that he could make this painting to exorcise the spirits, he was thinking perhaps of his innate terror of contracting syphilis – so, an exorcism against death too, which was always haunting him. Lydia Gasman points out that many of Picasso's paintings are connected with exorcism.[10] Braque on the other hand, according to Picasso, was 'never at all afraid' of the masks. 'Exorcism didn't interest him. Because he wasn't affected by what I called "the whole of it", or life . . . he didn't find all of that hostile. And imagine – not even foreign to him!'.[11]

Leo Steinberg, in his essay on *Les Demoiselles d'Avignon*, entitled 'Philosophical Brothel', calls the painting the 'perfect image of savagery in the midst of civilization',[12] and Richardson quotes Baudelaire: 'the charms of the horrible intoxicate only the strong'.[13] Braque, taken by Apollinaire to see the *Demoiselles*, said to Picasso: 'With your painting, it's as if you wanted us to eat tow or drink kerosene.'[14] Picasso himself, to hide the source of the painting, would divert conversation from it, so that there would remain something secret at its centre. His Catalan friend Zuloaga had in his studio at 54 rue de Caulaincourt one of the evident sources, El Greco's *Apocalyptic Vision* (1608–14). Picasso must have seen it there.

For the sketches and the working out of the painting, Picasso used his second studio in the Bateau-Lavoir, provided by the Steins, beneath his principal studio. It was now clear how firmly and irreversibly he had outgrown the kind of *Arlequin trismégiste* persona of his 'Rose Period', associated with his acquaintance with Max Jacob and Guillaume Apollinaire, and the kind of misty atmosphere that attached to it. He was never to outgrow the *Demoiselles*, and in fact painted and repainted the right-hand heads in a never-ending obsessive state. This repainting is what shocks most. As John Richardson put it, he had to present his 'revolutionary endeavour as finished. In fact his masterpiece is not so much unfinished as unfinishable. Hence its everlasting, open-ended fascination'.[15] And Christopher Green: 'we are left with unresolved ambiguity: stylistic, cultural, emotional ambivalence'.[16]

As for the fate of the painting, it hung for a long time in Picasso's studio, until his friend, the Surrealist André Breton, who had a superb eye for art, persuaded the very rich couturier Jacques Doucet, for whom he scouted out works of art, to buy it. Breton's letters to Doucet, from 1921 until the purchase in 1924 (for 25,000 francs, a sizable amount at that time), were convincing. 'It is a work', he said, 'which for me goes beyond painting, it is the theatre of everything that has happened over the past fifty years, it is the wall before which passed Rimbaud, Lautréamont, Jarry, Apollinaire, and all those whom we continue to love'.[17] And after the sale, Doucet exulted over the work, which he never ceased to admire, originally urged to that admiration by Breton: 'Here is the painting which one would parade, as was Cimabue's Virgin, through the streets of our capital'.[18] Until Breton discussed it at length, the work had not been perceived as revolutionary. In fact, it had not been perceived very much at all, and was only put on exhibition in 1916, when it was seen as a staggering innovation in the history of painting, as a revolutionary display of primitive strength and brazen daring.

The painting hung first in Doucet's house in Neuilly, on the landing of a staircase whose steps were silver and red enamel under heavy glass, between newel posts of birds. The stair had been planned by Doucet, and was executed by the famous architect Csaky, directly opposite doors by René Lalique. Then, at the liquidation of Doucet's estate, A. Conger Goodyear bought the painting for the Museum of Modern Art in New York, through the Seligmann Gallery, at six times the price for which Picasso had sold it. Alas, the frame by the famous frame-maker Legrain, sent by ship, never arrived at its destination.

The fullest documentation about *Les Demoiselles d'Avignon* is provided in a volume of the same name, edited by Christopher Green. Beginning with an outline of Picasso's life up to the time of the painting, it continues with a discussion of the figures as they first appeared, in the preparatory sketches, with a medical student and a sailor, and their disappearance altogether, when the right-hand figures came under the influence of the West African and Oceanic sculpture. At this point, the confrontation of the five figures in the painting with the spectator came into play, as Leo Steinberg argues as he revises his piece for *Art News* of 1972, in October 1988. Now he points out how the spectator has become the very centre of attention, with the 'startled consciousness of a viewer who sees himself seen' as a male sexual being. This brings up 'Picasso's naked problem', and the way that the spectator is made to take the place of the prostitute's client, as the table thrusts its way into his space with a violent energy that Steinberg terms an 'orgiastic immersion'.[19] In Green's volume, Louis Marin compares the confrontation with the spectator to Caravaggio's terrifying *Medusa* (in the Uffizi, Florence), and notes how Poussin, wanting to keep the surface of the painting smooth and forbid any reference to its own representative function (as Marin puts it, he wanted to 'repress the act of enunciating proper to any historic discourse'), could not abide Caravaggio, whom he found destined to 'destroy

painting'. Since he couldn't, in Poussin's view, compose a real study, he rejected perspective in honour of realism, that is, addressing the spectator directly: 'Look at me, I'm watching you!' The argument concerns, then, the passage from historical and impersonal statement of fact to the presupposition of someone speaking.[20] The direct address of the *Demoiselles* is its fascination for many of us, although for some it is perceived as a problem – we want to marvel at a distance, say the latter, and want very much not to be included in the representative system.

John Golding marvels that, although they saw the work so frequently (since they lunched in front of it), the other inhabitants of the Bateau-Lavoir said nothing about it: Apollinaire mentioned it not at all, and Max Jacob only once. Salmon spoke of it in 1912, in *La Jeune peinture française*, and André Derain claimed that one day, thinking of Balzac's *Le Chef d'oeuvre inconnu*, which Picasso had so grandly illustrated, the artist would be found hanged behind the painting. (Balzac's bizarre story, at once terrible and enlightening, tells of a painter, Frenhofer, who is eager to show two others – one of whom is the young Poussin – the recent work he considers so compelling, combining as it does Romanticism and Classicism. But they see only a female foot emerging from a swirl of uninterpretable lines. In despair Frenhofer hangs himself behind the painting.) Thinking then of the painting, Derain replied to it with a completely lifeless *La Toilette*, which he subsequently destroyed, perhaps understanding its milquetoast quality. Braque studied the *Demoiselles* hard, says Golding, but it always made Picasso's dealer Kahnweiler uneasy.[21] And that is probably the ultimate tribute to the work: it confronts us, wherever we are. (At the end of his life, aged 90, and in the South of France, Picasso was to paint a suggestive recall of the theme of the *Demoiselles*, called *La Fête à Madame*, 'Madame's Festival', with a circle of prostitutes surrounding their madam – cartoonish, one might think, but the theme it remembers and the canvas it brings back are not, especially for a painter

panicking about contracting syphilis and the memories of both Avignons.)

At the moment I write, the *Demoiselles* has just merited an item in the front pages of the *New Yorker*.[22] The article, by Calvin Tomkins, begins: 'It takes steady nerves to operate on a ninety-seven-year-old patient, especially when the patient is: (1) eight feet tall; (2) not sick; and (3) the cornerstone of modern art.' The restoration of 'Picasso's bombshell, whose value is literally incalculable', will provide a new shock to viewers because of its so different appearance: fresher, bright colours, fleshier flesh tones for the whole and very indecent work. It turns out that Jacques Doucet had had the painting relined, and that it had been varnished, perhaps, says Tomkins, because of the dangers of drink, from Doucet's guests in his Neuilly apartment, when it was installed at the top of the stairs, too easy to stumble up, to take a look. Perhaps the glass post-dated the varnish; in any case, the latter has now been removed, with the famous spit method. There remain some vertical cracks from the rolling and unrolling and re-rolling as Picasso moved it from studio to studio over seventeen years. But it has now come into its own.

In August 1908 Picasso went with Fernande to La Rue-des-Bois, 60 kilometres north of Paris, and painted landscapes, influenced by Cézanne and the Douanier Rousseau, for whom Picasso and Fernande would give a banquet in November. (From this occasion comes the often-quoted exclamation of the elderly Douanier: 'You and I are the greatest painters of our time, you in the Egyptian style, I in the modern' – !) Here in La Rue-des-Bois, Picasso went through a 'Green Period', after his Blue and Rose ones. He said later to André Malraux: 'I want to see my branches grow. That's why I started to paint trees; yet I never paint them from nature. My trees are myself.'[23] In his *Landscape with Figures*, in the Musée Picasso, a man turns into the trunk of a tree on the right, and on the left a woman turns into roots. In *The Farm Woman* (1908; Hermitage,

St Petersburg), he took delight in painting the massive body of the widow Putnam, a local figure in La Rue-des-Bois, as if she too were part of the natural landscape. Apollinaire came out to visit his friend and share his fresh view of the natural world.

But his friend Karl-Heinz Wiegels, a German painter, killed himself in the Bateau-Lavoir while Picasso was in the country, and on his return to Paris Picasso painted the stunning painting now in the Hermitage, *Still-life with Death's Head*, and began a whole series of still-lifes with geometrical forms. This September was the moment when Braque submitted his landscapes, also influenced by Cézanne (as were, of course, those that Picasso painted at La Rue-des-Bois, and later, at Horta del Ebro) to the Salon d'Automne, for which they were refused. Matisse, on the jury, remarked that Braque was 'making little cubes', and when in November Braque showed the landscapes at Kahnweiler's gallery, Vauxcelles's review in *Gil Blas* said that he reduced everything 'to cubes'. These two statements gave rise to the name for Cubism, which the art world had picked up by 1909. By some extraordinary coincidence, a sort of Surrealist *merveilleux* in everyday life, *Gil Blas* of the day of that review, 14 November, recounted the triumph of Wilbur Wright in his aeroplane at Le Mans, winning the *prix de la hauteur*. The Cubists would often associate flying and their art; both awarded a kind of summit prize in this great moment. 'Our future is in the air', Picasso wrote on three still-lifes of 1911.

Meyer Schapiro points out that the artist figure was emerging as triumphant in these years, picking up from the small figure of Picasso's *Boy Leading the Horse* of 1906 (Museum of Modern Art, New York), in all his classic elegance, to the crowning of the central figure with laurel leaves. The sense of drastic change, from the pathetic outsider figures of the Blue Period to these, and even in the alteration from the sketch of the *Woman with a Fan*, in which the gesture simply points downward, to the painting, in which the arm and hand are uplifted, signalling very clearly some sort of

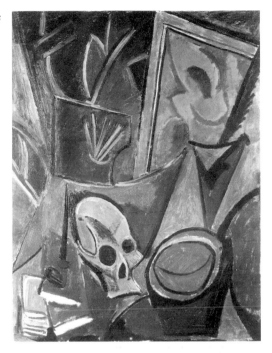

Still-life with Death's Head, 1907, oil on canvas.

command.[24] This is the time in which the young Picasso leaves his Blue and Rose periods, to move 'toward austerity, construction, precision, and control'.

After a trip to Barcelona, during which emotional difficulties between the couple so often surfaced (Fernande being far less attached to the city than her lover), Picasso and Fernande left the Bateau-Lavoir in the autumn of 1909 for 11 boulevard de Clichy, and a studio with north lighting, more ease and an increasing sense of bourgeois habit. They would visit Matisse on Fridays, would go to Gertrude Stein's on the rue de Fleurus on Saturday evenings, and would entertain on Sunday afternoons, in a semblance of ordered existence. It did not last, but it was another of Picasso's changing domestic styles. At this point, only Apollinaire

and Max Jacob could distract him from painting, and he was complaining of stomach ulcers, so, never a heavy drinker, he would drink only mineral water or milk, and eat just vegetables, fish, rice pudding and grapes.

Picasso had returned in May of this year to Horta del Ebro, where Pallarés had taken him eleven years earlier, and painted a series of Cézanne-type landscapes: this is considered to be the beginning of his Analytic Cubism period. Very roughly, in this early phase of Cubism, as Picasso and Braque practised it, the work of one relating to the work of the other, the emphasis is on the strokes and lines and planes making up the work, that is, on isolated elements, whereas in the next phase of Cubism, there would gradually develop more of a feeling of the whole, with a guiding melody: thus, Schapiro points out, all the representations of instruments and printing, elaborations on the issue of representation.[25] In 1910 Picasso exhibited with Braque, in Düsseldorf and Munich, and continued his 'Cubist' portraits. This was a year in which, instead of going to Collioure by the seaside, where there were 'too many painters', he and Fernande went to Cadaqués, where Salvador Dalí, then aged six but later a friend of Picasso, would one day be filming *L'Age d'or* with Buñuel. In 1911 there was a Cubist manifestation at the Salon des Indépendants, and in 1912, for that year's salon, there appeared the only issue of the Cubist journal *La Section d'Or*. Picasso, however, never showed in salons, disliking to show his work among that of others. He did not swerve from this policy until he exhibited with the Surrealists – a break in his attitude toward exhibitions that would be noticed widely, and for that very reason.

In July 1911 he and Max Jacob and Fernande, together with Braque, joined Manolo Hugué, an old friend from Barcelona, in Céret, a small town in the French Pyrenees. The works of this period and place are among the best known examples of Cubism. In the autumn, back in Paris at the Steins', Picasso met Eva Gouel (Marcelle Humbert), then the mistress of Louis Marcoussis (Lodwicz Casimir

Ladislas Markus), who managed to replace Fernande by a clever trick, interesting her in someone else and losing Picasso for her forever. Eva would be the muse of *Ma Jolie* ('O Manon, ma jolie, mon coeur te dit bonjour' / Oh Manon, my lovely one, my heart tells you hello'), and his mistress – greatly beloved – until her death, after a long illness, in 1915. Max Jacob's behaviour at Eva's funeral (stopping off for a drink, flirting with the coachman) shocked Picasso so greatly that their friendship began to cool. His relations with Fernande were, of course, over, and, after her memoirs were published in 1936, it was only the intercession of friends that motivated him, by then very rich indeed, to help her out in her distress as an old woman.

This is not to say, of course, that Picasso's attachment to Eva would be his only attachment during this period, for when Eva was in a nursing home, there was, and from then on for a few years, also Gaby Depeyre. Aged 27 when he met her, she became the model for a lovely nude pencil drawing, and a few works with phrases stencilled inside: 'Reviens Mon Amour Mon Ange / Come Back My Love My Angel' and 'Je t'aime Gaby'. But his love for one woman did not rule out his love for another (this is discussed further in chapter Six).

And in May of 1912 Eva and Picasso went back to Céret. They then left for Sorgues, near Avignon, and that autumn they moved to a new studio at 242 boulevard Raspail in Paris. Picasso always returned to Paris in the autumn, after a summer spent away. This was the year of the Second Post-Impressionist Exhibition at the Grafton Galleries in London, with thirteen Picassos exhibited, and also the time in which Picasso made his first *papiers collés*, about which Rosalind Krauss has written extensively in *Picasso Papers*. In this period of Synthetic Cubism, the emphasis would be, in the works both of Picasso and of Braque, on the painting as an object in the world outside it, on its 'thingness' – so in the *Still-life with Chair Caning* of 1912 (Musée Picasso, Paris) an actual piece of

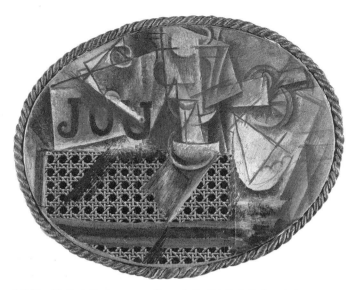

Still-life with Chair Caning, 1912, collage of oil, oilcloth, imitation chair-cane paper on canvas.

oilcloth is stuck on the canvas, itself framed with rope to stress the ambiguity of the simulated and the real.

That same year, 1913, Picasso made his Cubist portrait of Apollinaire for the frontispiece of *Alcools*. This was the masterpiece of all his Cubist portraits, and a fitting tribute to his equal, and the poet he most loved. Apollinaire's *Les Peintres cubistes: méditations esthétiques* opens with his painter friend, who haunted his mind until the very end of his life.

5

Poetic Cubism

His friends in Paris were writers rather than painters, why have
painters for friends when he could paint as he could paint?
Gertrude Stein[1]

The excitement of the first discoveries of Cubism remains as intense
as ever for the curious onlooker. The way that Georges Braque drove
his illusionistic nails through a canvas in 1909 – the length of cord,
the baton, the oblique angle – each of these constructions and col-
lages of these early years makes a point of convergence. Braque and
Picasso, 'roped together' on the mountain of discovery, as Braque
put it, made of their time together in the little town of Céret, in 1911,
the moment of Analytic Cubism, that is, a moment that lasted in
art. Picasso returned to Céret in 1912 and 1913 – he was fond not
only of shifting points of view and techniques, but also of returns,
as if the Cubist notion of *passage*, or the passing of one plane to the
next, were to have been part of his mental make-up.

Metaphorically as well as actually, the term *passage*, for which
Cézanne is often the reference, illuminates not only the art objects
but the literary ones. We might (and often do) take the word to
mean an elision of planes, or, as Alfred Barr defines it, 'the merging
of planes with space by leaving one edge unpainted or light in
tone'.[2] Braque's 'new space' in his landscapes allowed the open-
sided planes to elide into each other, while Picasso emphasized
what happened in the mass or the material of objects.[3] And in

Horta del Ebro, where Picasso's Barcelona pal Pallarés had invited him, the landscapes that Picasso painted already reflected an attempt at Analytic Cubism. Gertrude Stein, as she had done for the inventions of Picasso before, defended him as the maker, inventor and genius of Cubism – perhaps because she collected the works of Picasso the Spaniard and not those of Braque the Frenchman. Cubism, she said, is part of daily Spanish life and architecture, that 'always cuts the lines of the landscape, and it is that that is the basis of cubism, the world of man is not in harmony with the landscape, it opposes it'.[4]

The Cubist painters, she said, used real objects, painting them with such intensity that the painted ones might well replace the real ones. This is reminiscent of Picasso's attitude towards the 'Buffet Catalan', a sideboard in the Catalan, a restaurant on the rue des Grands Augustins, where the 'bande à Picasso' ate every day for years. Robert Desnos, a Surrealist poet and novelist, tells the story in his last essay, called simply 'Le Buffet Catalan', then Roland Penrose retells it, and Dore Ashton quotes it again, giving all the more layering to the substance of the tale and the sideboard. Picasso said:

> I had lunched at the Catalan for months, and for months I looked at the sideboard without thinking more than 'It's a side-board.' One day I decide to make a picture of it. I do so. The next day, when I arrived, the sideboard had gone, its place was empty . . . I must have taken it away without noticing by painting it.[5]

The force of such imaginative representation is undeniable, even in the tall tale.

Some of Stein's statements about the whole topic of Cubist art in its national basis take our breath away. For example, 'Nature and man are opposed in Spain, they agree in France',[6] which ends up meaning that – we are getting Stein's view, of course – since in

Spain the round is opposed to the cube, the movement of the earth is against the movement of the houses, whereas in the less perceptive France, 'the houses move with the landscape'. In the 'Testimony against Gertrude Stein', published in Eugène Jolas's *transition*,[7] Braque wrote that 'Miss Stein understood nothing of what went on around her . . . It is obvious that she never knew French very well and that was always a barrier. But she has entirely misunderstood Cubism which she sees simply in terms of personalities.'[8] Among other things, he said, he and Picasso had joined in a 'search for the anonymous personality. We were inclined to efface our own personalities in order to find originality.'[9] Eugene Jolas was no more flattering about Miss Stein's 'hollow tinsel bohemianism and egocentric deformations'. So much for Stein's myth of Picassoist lonely glory.

Unlike, say, Dada, Futurism and Surrealism, Cubism had no manifesto. The 'little cubes' that the critic Louis Vauxcelles attributed to a painting had no real reason for sticking, and the only real theory of Cubism was written by Albert Gleize, in 1912, years after Picasso and Braque began their way of seeing an object from all sides, which became the defining criterion of yet another 'ism'. But it was as if the term had been sorely needed, and, in retrospect (of course), *Les Demoiselles d'Avignon* has been called proto-Cubist.

Max Jacob had already been writing 'cubistic' poems in the Bateau-Lavoir. Of the other literary poetic Cubists, apart from Max and Guillaume Apollinaire, the most famous were Blaise Cendrars and Pierre Reverdy. These figures were already involved in their revolutionary avant-garde writing before there was ever anything spoken of under the title Literary Cubism, or any general sense of what Tim Hilton has so accurately called 'the haughty privacy of Cubism'.[10] Reverdy had arrived from Narbonne in October 1910 at the age of 21, and lived in the Bateau-Lavoir, where he met Max and Juan Gris (Picasso had moved from the Bateau-Lavoir to 11 boulevard de Clichy in 1909). His *Petits poèmes en prose* of 1915 were to be

the apex of Literary Cubism. Gris and Reverdy worked well together, and their still-life poems and canvases remain a high point, one of Gris' paintings even including an entire Reverdy poem. Gris' early death, on 7 May 1927, cut short one of the most impressive collaborations of Cubism. Picasso paid Gertrude Stein a condolence call; but in her *Autobiography of Alice B. Toklas*, she wrote: 'Juan Gris was the only person whom Picasso wished away. The relation between them was just that.' That Gertrude was so fond of Juan Gris irritated Picasso. 'Later', wrote Stein,

> when Juan died and Gertrude Stein was heart-broken Picasso came to the house and spent all day there. I do not know what was said but I do know that at one time Gertrude Stein said to him bitterly, you have no right to mourn, and he said you have no right to say that to me. You never realized his meaning because you did not have it, she said angrily. You know very well I did he replied.[11]

Picasso was the only painter to whom Reverdy had ever applied the word genius. He wrote a monograph on the painter (published in 1924, as simply *Picasso*) and in Cannes he engraved the following poem for his painter, on clay tablets:

> *Dans la marge aride du temps*
> *A travers ce coeur nu qui*
> *Déborde l'amer*
> *Picasso*
> *graine au vent qui peuple*
> *les deserts.*[12]

> In time's dry margin
> Through this bare heart that
> Spills over bitter

Picasso
seed in the wind populating
deserts.

Literary Cubism enjoyed and still enjoys a considerable esteem
and is responsible for some of the most interesting poetic texts
around. Take the poem of Pierre Reverdy called 'Carrés' or Squares
of 1916:[13] it is simply a text that appears in various cubes upon the
page and looks more impressively cubistic than anything had
before. The still-life included in the poem is at once daily and
visionary, as in this central cube:

> *Le rhum est excellent*
> *la pipe est amère et les*
> *étoiles qui tombent de*
> *vos cheveux s'envolent*
> *dans la cheminée.*

> The rum is excellent
> the pipe bitter and the
> stars falling from
> your hair are flying
> into the fireplace.

Visual poetry makes its own effect, and nothing better expresses
a certain cheerful genius than Guillaume Apollinaire's poem for
Picasso, published in *sic* for May 1917, in which the central empty
spots left between the textual lines make the outline of a still-life.[14]

Apollinaire long had the project of putting his lyric ideograms
together, with Picasso's poems in their combined volume, so that
the interchange between visuality and the verbal might serve as
a clear witness. The compilation was to be entitled *Et moi aussi
je suis peintre* (And I too am a painter). The project was aborted,
and Picasso feared the domination of Apollinaire in it: but the

'Cœur coronne et miroir', from Guillaume Apollinaire's 1918 book of visual poems, *Calligrammes*.

latter was very certain about being a painter himself, just as he said.

It is very clearly the case that no poet ever described Picasso's paintings better than Apollinaire. The insertion of letters into the Cubist *tableau-objet* is an innovation that went far: the loving 'Ma jolie' salute to Eva in the paintings of 1912, the phrases about flight, lifting the Cubist painting to the adventure of the Wrights in the sky, and the simple three-letter *Jou* for *journal* appearing in still-lifes are all testimonials to the adventure of painting in these years. The poems of the Cubists Apollinaire and Cendrars are full of references to travelling and in particular to flight: Apollinaire's great poem 'Zone' has Christ flying through the air, and Cendrars' 'Le Panama ou les aventures de mes sept oncles' (Panama or the adventures of my seven uncles) declares that 'Poetry dates from

today' and elevates the poet accordingly: 'I am the first pilot to cross the Atlantic solo.'[15] When, in 1912, Picasso constructed his *Still-life with Chair Caning* (Musée Picasso, Paris), in which an actual rope frames the oval of the work, inviting the real and material world to enter the canvas along with wallpaper and paint, the joining of simulation and verification is as much part of news as the newspaper, still folded, in the painting. Meyer Schapiro calls this kind of assured experiment part of the 'free cubist constructed manner', proving the stance of the artist as manipulator, so that his personality returns. Schapiro continues to say that Picasso as Harlequin is, all the same, the Picasso self, in his 'statuesque presence'.[16] The advantage of this oval form, so frequent in Cubist works, has two functions, according to Tim Hilton: it reinforces the idea of the object in its full presence rather than its representation, and it eliminates the issue of the internalized structure not reaching the framing edge.[17] He says of Picasso's painting of these years that it exhibits a 'real oddness . . . a picture-making simultaneously weird and jaunty'. Of the celebrated *Guitar* (a construction that, through William Rubin's friendship with the painter, was given to the Museum of Modern Art in New York), he writes that this was the first sculpture 'that was a still life', innovative by its putting of parts together 'instead of modelling and carving',[18] making way for the free-standing sculpture of 1914, the *Glass of Absinthe*.

The dialogue between Picasso and Braque, from 1905 to 1918, bears testimony, as Pierre Caizergues puts it, to 'a friendship always exigent, often complicitous, sometimes wounded, carried on between two creators'.[19] Picasso wrote 113 messages to this friend, but only 51 to Apollinaire, if we judge by the extant material, and it is as if Apollinaire replied in his poetry. 'Fiançailles' is dedicated to Picasso, and the poet sent him the poem 'Saltimbanques', with 'Spectacle' which would become, with its rose hue, the pink atmosphere of twilight, or 'Crépuscule'– all related to Picasso's circus or Rose Period, previously discussed. And Picasso is the first in the

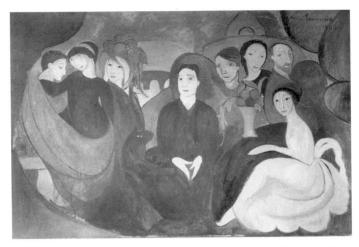

Marie Laurencin, *Guillaume Apollinaire and his Friends* (*Gathering in the Countryside*), 1909, oil on canvas.

series of the *Peintres nouveaux* in Apollinaire's reflections on painters of 1905, included in *Apollinaire on Art*.

Relations between Apollinaire and Picasso were warm for a very long time: the letters of Picasso to his poet friend manifest a kind of joyous intimacy. From 1908: 'Bonjour mon cher ami Guillaume ye te embrase et precicement sur ton ombril' ('Hello very dear Guillaume I kiss you and right there on your navel . . . I'm sending you a few little drawings'), and wishing him 'a year and a thousand of glory and happiness'.[20]

But things were not always so simple. Writing on Sunday, 8 March 1908, Picasso wonders about some tales the friends around them were telling: 'Dear friend I read just this morning a letter from you to Max, and really I don't understand – you don't ever come to see me and you say I don't love you any more'.[21] Their relations, however, were always patched up somehow. Apollinaire would write an article on Picasso, and he and Marie Laurencin would go to dinner at 11 boulevard de Clichy – it was,

after all, Picasso who had arranged their meeting the year before, at the gallery of Clovis Sagot, the former clown, now a dealer.

Yet, on the more difficult side of the relationship, the idea that Apollinaire seems to have had in mind on their joint productions came in great part from the fact that he always wanted to remain in charge, with Picasso as the illustrator – the evident strain in the close relationship of two such vivid creators. But Apollinaire wrote on Picasso in an article for the *Mercure* in 1914, and again in 1917, with his poem 'Pablo Picasso'.[22] He had wanted them to produce 'A BOOK ON YOU UPON WHICH WE WILL WORK TOGETHER, that is to say that you will give me the information, and it will be interesting and important'. Picasso always would have liked more correspondence from his friend. Writing to Apollinaire at his apartment at 202 boulevard St Germain, from Céret, on 18 March 1913, Picasso makes this very evident:

My dear old Guillaume
You never write me in spite of all the Catalan cards I send you.
I'm working and thinking about you.
Best wishes for you,
Picasso[23]

In this year Apollinaire's celebrated poems called *Alcools* were published, and Picasso received them, writing on 29 May 1913: 'You know how I love you and you know the joy I have reading your poems, I am very happy. Me, I'm working.' And he sent him a little 'guitar that I made for you'.[24] Apollinaire shared with Picasso his point of view about his poems, writing in excitement on 4 July 1914, about his graphically interesting 'Lettre-océan', hoping Picasso got it, and continuing: 'Did you get the 'Lettre-océan? Since then, I've made still newer poems, real ideograms which take their form not from some prosody but from their subject itself . . . I think it's a great novelty and I'll write a little poem

for you here'. And then he adds two visually interesting poems, 'The Pipe and the Brush' (the Pipe: 'I am the form itself of the meditation / and finally I contain no more than ashes / too heavy a smoke and can only sink down'; the Paintbrush: 'But the hand that takes you up contains THE UNIVERSE / immobilizes a whole life / here are born / all the aspects / all the faces/ and all the landscapes').[25]

In December 1916 Apollinaire wanted to get out into the open a discussion of 'our characters, our complaints, in a word, our friendship . . . My feelings are vital and strong about you, which doesn't keep it from bleeding here and there'.[26] When, after Apollinaire's death in 1918, Françoise Gilot tried to gather up all the pieces of the correspondence and proposed material, Picasso refused to lend what he had from the studio on the Grands-Augustins, and said: 'It is too much of a bother. And anyway, to keep alive Apollinaire's memory, the poems everyone knows are enough. Useless to add mine to them.'[27]

An odd footnote about Apollinaire's memory: instead of the monumental sculpture that Picasso had planned in his honour (in 1928, a wire construction that was to have been 13 feet high) there was finally erected, in the little square behind the church at St Germain-des-Prés, a statue on whose base is inscribed *Apollinaire, Prince des Poètes*. For years, I wondered why the head seemed unlike his, until I learned that it is Picasso's head of Dora Maar, placed there in 1959, unveiled in a ceremony by his widow Jacqueline, attended by André Salmon, André Billy and Jean Cocteau. It is, in fact, the second head of Dora Maar that Picasso made, because the first had turned green when he had watered it with his urine to give it a patina. Lest this seem strange, he had acquired this notion from Maillol, who, it is said, watered all his statues in that fashion every morning. More bizarre still, the second head was stolen a few years ago, after the sale of Dora Maar's estate, and then retrieved from a forest and replaced – one more adventure in the field of Cubist poetry.

As leading practitioners of Cubism, besides the early founders Picasso and Braque, whom Picasso called, upon occasion, his wife, there was also Juan Gris, another Spaniard, who always referred to Picasso as his mentor. Gris was a part of Picasso's circle from 1906 in the Bateau-Lavoir, where Picasso found him a studio, which he used until 1922. But he was so much of a worrier about things physical and psychological that he was a constant source of irritation to Picasso and to Max Jacob. Picasso found Gris grim and stiff; he was too fond of making proclamations and defining theories in the various cafés they frequented. Blaise Cendrars, who was along with Apollinaire the most humorous of the bunch, sent Picasso a postcard in 1917 mocking the seriousness of the café discussions. He and Picasso were on the side of informality.

Gris always felt himself a stranger, and of course his almost paranoiac laments did nothing to make him feel a part of the Parisian scene. Things were never on his side. Penniless, he had a particularly hard time during the Occupation, and it is said that when Gertrude Stein, who was fond of him and to whom he had appealed, was about to help him, Picasso stood in the way. In any case, their relationship was very far from ever having the warmth of that with Max Jacob and Apollinaire. In March 1917 he writes to Picasso telling him how it is incredibly depressing in Paris, where there is 'a boring atmosphere',[28] how he feels he is living among madmen, and how affectionate people like Picasso are rare. And again on 13 April: 'Besides a great laziness and depression, I have a total lack of conviction . . . Spring is equally unhealthy for work and every year at this period I have depressions very long and black.'[29] So of course Picasso is right to stay away from 'frighteningly boring' Paris as long as possible. And indeed he did. A dinner for Picasso was planned and took place, but no Picasso.

Gris continued to lament the hostility in Paris towards all foreigners, and to plead for Picasso to help him with his 'possibilities and influences'. He hasn't, he says painted anything since Picasso left,[30] and is depressed beyond belief. But then he assured Picasso,

who had criticized his early Paris works (a criticism Metzinger agreed with), that he too found them 'dull and lifeless'. 'I think I have made the latest ones less boring and more vital. If you were to see some of them I hope you wouldn't be discontented with your pupil' (18 August 1918).[31]

Picasso's friend from Barcelona, Manolo Hugué, had a great 'antipathy for Gris . . . that only a hot-blooded, mocking Catalan steeped in the classical tradition could feel for a cerebral and humourless modernist from Madrid, who was a much more imaginative and inventive artist'.[32] At this point, Gris had caught up with his mentor, Picasso, and had stepped into Braque's shoes. In fact, the first Cubist collages were by Juan Gris, his *The Lavabo* of 1912, with a piece of a mirror stuck on its canvas, and, in the same year, *La Montre*, with a paper inscribed with Apollinaire's poem 'Le Pont Mirabeau': 'Sous le pont Mirabeau / coule la Seine . . . / Vienne la nuit sonne l'heure / Les jours s'en vont je demeure'. Inscriptions, insertions, references: this is all part of the grandeur of poetic Cubist collage.

Rosalind Krauss, in *The Picasso Papers*, examines collages in their non-reference to the world, of having 'entered a space in which the sign has slipped away from the fixity of what the semiologist would call an iconic condition – that of resemblance – to assume the ceaseless play of meaning open to the symbol, which is to say, language's unmotivated, conventional sign'.[33] The collage takes on the aspect of conversation, then, like Apollinaire's conversation poems.[34] Clearly, Apollinaire was in conversation with Picasso, they with each other . . .

One day, much later, looking at one of his own collages from 1914, Picasso turned to his companion, Fernand Léger, and said: 'We must have been crazy, or cowards, to abandon this! We had such magnificent means. Look how beautiful this is . . . and we had these means yet turned back to oil paint and you to marble.'[35] It is, in this statement, the idea of 'turning back' that grabs you, as if

Cubism and the Cubist collage were indeed the most revolutionary aspects of Picasso's art, and of Braque's . . . perhaps they were.

One of the most moving aspects of the adventure that was Cubism (that moment, to take John Berger's term in his meditation on 'The Moment of Cubism') is the way it had to end. And it ended in Avignon, when, Tim Hilton points out, 'In the late spring of 1914, at Avignon, Picasso and Braque painted together for the last time.' Other commentators stress the final moment as that in which Picasso bids farewell to Braque and Derain in the train station at Avignon in 1914, and remains there for the rest of the summer with Eva. This bidding farewell to things, to adventures, to mistresses, to friends, was something that Picasso did not make a big case about – but we can do just that.

Picasso had indeed exulted in the moment of his Cubist collages, Stein affirmed, and in his constructions, which he loved making out of zinc, tin, pasted paper: 'He liked paper, in fact everything at this time pleased him and everything was going on very lively and with an enormous gaiety.'[36] Everything about his inventions and constructions bears the mark of genius. Even a guitar of 1919, now in the Museum of Modern Art in New York, used a discarded design for *Le Tricorne*. There were paint and cuttings and pins, with a paper cut-out pinned in place, and a folded strip of newspaper: all very simple elements, made into a convincing work of art. This was sold, also in 1919, to Pierre Loeb, the dealer for the Surrealists, who were most of them great admirers of Picasso.

Reverdy wrote about this guitar, in his 'Le rêveur parmi les murailles' (in *La Révolution surréaliste* of 1 December 1924), as if it were a waking dream, about the Surrealist dreamer's relation with reality. Particularly apt, since this is exactly the way that Breton praised Picasso's Cubist work in his 'Picasso dans son élément', in *Le surréalisme et la peinture*. First of all, Cubism was about seeing things differently. Picasso was always making and taking fresh views, originating in himself and also in others. From other painters, he took

what he admired, wanted and needed. From the Douanier Rousseau, that twentieth-century primitive, it was his hard-edgedness and his 'innocence of vision'.[37] In the early days, as Max Jacob recounts, when Matisse lived at 19 quai Saint-Michel, he and Picasso would discuss his theories of colour, the relations between the painted surface and the colouration. Once, Matisse showed Picasso a statuette in black wood, and Picasso held it in his hand the entire evening.[38]

From Matisse, whom he came to visit at the end of that painter's life, when he was making cut-outs, he took that idea, saw what he wanted to see, and never returned. That is Matisse's view of things, of course, but it has the ring of truth. Picasso paid homage to Matisse often, and visibly, even in the making of his statues such as the *Flute Player*. Picasso's homages, whether spoken or unspoken, when they are not the obsessions of a series, do something quite unlike the rest of his work – they both refer and inaugurate.

The preface by Jack Flam to his magisterial study of the two great painters of the twentieth century ends with a discussion of the 'synergetic effect' of seeing their works together, as if each of the two were greater in their impact in this double consideration, as they both seem to have understood, spurring each other on for half a century. Throughout their lives, from the first time they met, each recognized that the other would somehow be the main presence that he would have to reckon with. 'All things considered,' Picasso remarked, 'there is only Matisse.' Matisse, for his part, said: 'Only one person has the right to criticize me, that is Picasso.' And more than once, both of them were reported to have said something to this effect: 'We must talk to each other as much as we can. When one of us dies, there will be some things that the other will never be able to talk of with anyone else.'[39]

That conversation is the true essence of the term, despite the disagreements, envies and the other pettiness that creators, like all flesh, are heirs to. Only Max Jacob's admiration of Picasso

knew no bounds, or at least expressed none, when they all lived together in April 1913, again at the Maison Delcros in Céret, where Picasso and he and Braque had been in the summer of 1911 and where Picasso and Eva had also been briefly in 1912, before leaving for Avignon. Here is Max writing to Kahnweiler in April 1913: 'You only know your friends after living with them: I learn every day to admire the greatness of the character of Picasso, the real originality of his taste, the delicacy of his senses, the picturesque details of his mind and his really Christian modesty.'[40]

In 1913 Picasso's father died. At the time Picasso was illustrating Max's *Siège de Jerusalem*, and he chose a still-life with a skull, perhaps a reflection of that death. In any case, he worked as always: 'Ye travail', he wrote. And then, in mid-June, Picasso, Eva and Max, another trinity after that with Apollinaire, went to Figueras and Girona to watch bullfighting as only the Spaniards could do. Picasso's entire life was presided over by the image of a bull, from the *Minotaur* paintings to his own picturing.

Returning to Paris in September, Picasso found a studio at 5 bis rue Schoelcher, opposite the cemetery in Montparnasse and Max Jacob. He preferred apartments to the studios, where you often either burnt or froze. The next year he tried Tarascon, then in 1923 Avignon, a city he had visited with Eva, now living there from 1923 to 1928 in the Grand Nouvel Hôtel d'Avignon, then on the rue Saint-Bernard. Picasso's generosity to Max at this point was unreserved. He had always sent him drawings and sketches that Max could sell (as he could not Picasso's letters, of course), and when Jacques Doucet had been brought to meet the painter, whose *Les Demoiselles d'Avignon* he would eventually purchase, through the persuasion of André Breton, Picasso persuaded him to buy some of Max Jacob's books, so that he could have enough money to return to Paris. For Doucet, Max also recopied manuscripts for money: the prose poems of his *Le Cornet à dés*, and also the *Chroniques prophétiques et retrospectives*. And when Picasso moved from the rue

Schoelcher to Montrouge, after Eva's death, he sent Max ('mon cher filleul') the money from the two books he himself had sold. Max had not wanted to talk to Doucet about his relations with Picasso, saying that he'd never written about Picasso, who hated being written about, having a horror of 'misunderstanding and indiscretion, and I have such respect for him and so much gratitude that I would not want to do anything to displease him'. On top of that, he said, whatever he would write would attract more attention than anyone else, and he'd be 'reduced to being "Picasso's friend"'.[41] But later he relented, and made these notes about his pal:

> Little, dark, solid, unquiet, with piercing somber eyes, great
> gestures, little feet and hands
> Brutal disorder and anger
> A table open to everyone
> Not made for Paris
> A mattress for his friends
> 'Are you working?'
> Espadrilles. Old cap, much washed
> A smell of dog and paint
> Vegetable cart chatting in front of the door
> A continual procession of Spanish women
> The safe: an interior pocketbook with a pin
> distrust
> All the dealers at five coming around
> Matisse bringing M. Schuchkin
> Showed great friendliness to visitors he cussed under his breath.

About their relationship, Max said it best, talking to Tzara the Dadaist: 'Picasso has been my friend for 16 years: we have hated each other and done each other as much harm as good but he is indispensable to my life.'[42] When Max the Jew became a convert to

Catholicism, his best friend Picasso would be the godfather. He wanted to give Max the baptismal name of 'Fiacre' (the patron of gardeners and of sufferers of haemorrhoids), thinking it appropriate for 'late conversions' – but alas, the term *fiacre* had been already used for the cabs for hire. So, for Max's baptism, on 18 February 1915, he chose the name Cyprien, meaning 'croissance'.[43] Picasso inscribed his gift of an *Imitation of Jesus Christ*: 'To my brother Cyprien Max Jacob, in memory of his Baptism', just a month after painting his famous Ingres-styled portrait of Max in January. (Ironically, when Dora Maar became a religious recluse after her time with Picasso, she sent Picasso an *Imitation of Jesus Christ*, a gift he made fun of, as we might have suspected. Max and Dora were different beings, and the older Picasso was a different one from the godfather of Max.)

Picasso, as we know, changed a great deal over time, not just in his personality and in his dwellings – from the ramshackle and splendidly dirty and communal Bateau-Lavoir to the bourgeois location of his rue de la Boétie apartment to his isolated and magnificent châteaux of Vauvenargues and Notre-Dame-de-Vie – but also in his galleries and dealers. When, for example, in 1916, Kahnweiler, a German, had to live in neutral Switzerland, Picasso had other dealers: Léonce Rosenberg (author of *L'Effort moderne*, 1918), who had already a stock of his works, having been advised by André Level and by Max Jacob. Picasso would be leaving him, however, for his brother Paul.

But his friends were among the most unchanging things in Picasso's life. Everywhere in his Cubist still-lifes there are references to them: Gertrude Stein's calling card in *The Architect's Table* of 1912 (Museum of Modern Art, New York), or Max Jacob's cigarettes and the lettering JOB in another, for Max was 'as poor as Job'. The quarters changed far more than the friends. One of the best descriptions of the change from Montmartre, and the Bateau-Lavoir / Lapin Agile scene to Montparnasse and the Dôme /

Rotonde cafés, is Max's. He had been asked to write, for the *Dictionnaire biographique des artistes contemporains*, his own notice:

> In 1898, I knew Picasso: he told me I was a poet, it's the most important revelation of my life after that of the existence of God. Together we were with all the artists of that 1900 epoch, all of them ardent and disinterested. Near us were Apollinaire, Salmon, and many many others who have become famous since then.[44]

And then, in the *Nouvelles littéraires* of 30 April 1932, he wrote on the 'Naissance du cubisme et autres' ('The birth of Cubism and other movements'), calling the *Demoiselles* with Negro art as its catalyst the initial manifestation of this movement, and depicting the atmosphere of the period, at the hour of the *apéritif*, outside the cafés on the boulevard Clichy, and Picasso, 'this eighteen-year-old Bonaparte', living at no. 130.

This was the epoch of Baty the wine merchant, of Hazard's grocery, and of Apollinaire's *La Femme assise*, as 'The truth is that Montparnasse replaces Montmartre, the Montmartre of former days, with its artists, chansonsonniers, moulins, cabarets, even its haschisch takers, the first opium addicts, the semipiternal erotomaniacs and cocaine users'. Now there were Marie Vassilieff (her studio at 21 avenue du Maine), Moïse Kisling, André Salmon and Amedeo Modigliani.[45] Recalling the two beloved others in the Bateau-Lavoir trinity, Max wrote:

> my two pals were not intellectuals. Picasso was too Spanish and too integral, Apollinaire too Italian to be what you would call an intellectual: he was a learned cavalier gentleman. Apollinaire and Picasso were never Montmartrois. Apollinaire called Montmartre 'Montmerde', we have to know that and remember it.[46]

Seeing Picasso through Max's eyes is at once illuminating and painful. His description of Picasso's pockets: what he carried in them was a prelude to the abundant Archives Picasso, already containing a universe of memory:

His pockets were mazes! At each departure from the Cubist Acropolis, with his cap on his stiff hair . . . First his revolver, a copper talisman [this is the one Max had engraved his scribblings on, which Picasso kept with him always], his handkerchief, one or two baggage labels, his pipe! A disorganized assembly of dirty old letters! A post card with pallettes! Spilled tobacco! A packet of tobacco cut out like a cover with incisions on the opposite side from the band closing it! One or two used subway tickets, and some official receipts that he called 'the little papers', like postal receipts, convocations, and some bills.[47]

Max worried, from the beginning, about Picasso's overbearing influence on him, about his having a woman and Max's 'having to put up with her or leave', neither of which he could stand, in principle. However, of course, he did in practice, put up with Fernande and Eva, even as his various worries persisted. Then in 1937 he delighted in welcoming Picasso for New Year's Day, and in their laughter and tears together. But subsequently he believed that the painter was mocking him. Writing to Liane de Pougy in May, he declared: 'I have no one any more.' He describes their getup in the first fifteen years of the century, which was a sort of homage, since he speaks of: 'affecting the caps, pipes, revolvers which seemed to us the height of chic and talent, only adopted to imitate Picasso'. Picasso remained the hero.

Our love of purity was above all our scorn for the unnecessary. We no longer loved an art that reveals its techniques, we needed to say in a few words, clear or less so, what we had to say; and

notice how the poems of this time are short, short, like a cubist painting which makes do with a few lines to express a form.[48]

Picasso would send Max funds ('Bless Picasso's heart'), and Max wrote to Salmon how much they owed to him ('we don't quite know what, but a lot'). He repeatedly asked everyone for news of his friend the painter who never wrote to him, and who 'when he had me right there neglected me'.[49] When, in 1941, under the German occupation, he was arrested and taken to Drancy concentration camp, the portrait of Picasso he had painted was found on his work table. The letter that Jean Cocteau wrote to the German authorities said:

> I'd say he was a great poet if it weren't a pleonasm. You have to say he's a poet, because poetry inhabits him, and escapes from him, through his hand, without his wanting it to. With Picasso, he invented a language flying above ours and which expresses the depths.
>
> He was the troubadour of this extraordinary jousting where Picasso, Matissse, Braque, Derain, Chirico . . . set out against each other their bright-striped shields.
>
> PS. He's been a Catholic for 20 years.[50]

Max died at Drancy on 5 March 1944. Poets and painters – Picasso, Salmon, Derain, Braque, Reverdy, Eluard – were among those who attended his Requiem Mass. That October, Bébé Bérard, the designer and social personality, came to a dinner wearing Max's pants, which he pointed out to Picasso, with some sort of misplaced pride. Picasso exclaimed in horror: 'It's the height of disrespect!', and left, slamming the door. When Michel Leiris presented a 'Hommage à Max Jacob' in the theatre of the Mathurins on 3 November, Cocteau and Picasso were there. Picasso presided over the Amis de Max Jacob as he hadn't wanted to for the Comité

Guillaume Apollinaire. Legend, interpretation and sentiment have it that Picasso's very great painting, *Three Musicians* of 1921 (Museum of Modern Art, New York) – in which Meyer Schapiro hears the strands of jazz music, and in which other interpreters lament the flat theatricality, superseding Cubist complication – suggests Picasso with his two Cubist poet friends, Apollinaire and Max Jacob.

The Cubist moment ended in 1914, on the large scale with the outbreak of war in Europe, and on the local and personal scale with the departure of Braque and Derain from the train station at Avignon, on 2 August, where Picasso was saying his farewells to his friends and to the Cubist moment of collective excitement. When he said 'Nous ne nous sommes jamais revus' ('We never saw each other again'), what he meant, of course, is that it had all changed after the war, to a spirit of melancholy.[51]

6

The Ballets Russes

The important thing is to do, and nothing else; be what it may.

Picasso, quoted by Sabartés [1]

A sense of abandonment after the train station send-off, a *retour de la gare* feeling, seems to have invaded Picasso now in Avignon, as he became a displaced foreigner, a '*Cézannean grand isolé* in the Midi'.[2] *The Painter and his Model* of that period was kept from the public and left unfinished, perhaps in a recall of Cézanne's unfinished work, Kenneth Silver suggests. Directly thereafter, in the naturalistically drawn portraits of Max Jacob and Ambroise Vollard, 'Picasso has simultaneously lowered his sights and worked up his technique', paying homage not to Courbet or Cézanne but to the ultra-conservative Ingres.[3] Yet again, Picasso is showing that he can do it all, can be the most far-out and the most traditional: no wonder he aroused such accusations of *arrivism* and worse.

At the end of the *annus terribilis* of 1915, when Braque had been wounded in the head fighting in World War I, when Picasso's beloved Eva Gouel was dying (she died on 14 December), and when the feeling in Paris was anti-alien, when his dealer Paul Rosenberg was exiled from France, Picasso moved out of Montparnasse to the suburb of Montrouge. And, in this low period, late in 1915, Picasso met the very high bourgeois Jean Cocteau, through the composer Edgar Varèse. Of this meeting and this atmosphere, Cocteau wrote:

Picasso and Jean Cocteau in 1958.

There were two fronts: the war front and then in Paris there
was what might be called the Montparnasse front . . . which
is where I met all the men who helped me emerge from the
famous Right in which I had been living . . . I was on the way to
what seemed to me the intense life – toward Picasso, toward
Modigliani, toward Satie . . . Picasso at once considered me a
friend. And took me around to all the groups. He introduced
me to the painters and poets . . . There were no politics at the
time, no political Left or Right, there was only a Left and Right
in art, and what we were full of was the patriotism of art.[4]

Paris: the Right Bank and the Left Bank. That we understand
from the language. And then there is Diaghilev, at once Right and
Left, with his style and his scandal. His Ballets Russes and Picasso's
Cubism were to meet, through Cocteau, in the late spring of 1916.

Now this was the year in which finally, *Les Demoiselles d'Avignon*
was exhibited, at the Salon d'Automne, thanks to André Salmon;
and the year of the founding of the Cabaret Voltaire in Zurich, by
the Dadaist Hugo Ball, which can be taken as Surrealism's basic

source; and when the first number of the journal *Littérature* appeared, edited by three original founders of the Surrealist movement that would soon burst on the Paris scene, in 1923: *Lis-tes-ratures*, 'read your scrapings', the title says ironically, or then 'beds and scrapings': *lits-et-ratures*. And then came the Cocteau–Picasso involvement, to which many commentators on Picasso ascribe his work with the Ballets Russes, which is considered more facile and less inventive than the previous ones. In this view, Cocteau figures as the culprit.

Max Jacob, always fascinated with Picasso and his hangers-on, was deeply suspicious of Cocteau with his elegance, panache and ease, and loved to describe how Cocteau would make his 'assault' on Picasso. Over and over, he would leave gifts large and small for him, would write to him incessantly. Cocteau had 'hollow rouged cheeks, thick, dark curly hair above a high forehead and very large black eyes. Always elegantly dressed, he heightened his complexion with lipstick.' This was Bronislava Nijinsky's description of Cocteau, about whose make-up she asked her brother. 'It's very Parisian', said Nijinsky, 'He advises me to do the same . . . rouge my cheeks and lips. It's the poet, Jean Cocteau.'[5] Enough said: he struck Picasso as a subject, and eventually Picasso made a portrait of him. Of course, Max Jacob was never entranced by Cocteau, to understate the case. Nothing could have been much further apart than his way of being and dressing and living and that of Cocteau, who, along with the Count of Beaumont (the Comte d'Orgel in Raymond Radiguet's novel of the same name), wore silk pyjamas and gold ankle bracelets. Both of them served in the ambulance corps gladly, because the ambulances had showers and were popular. Max, who knew what God liked and didn't, complained 'God hates Cocteau'.[6]

In any case, Picasso did not. And meeting Picasso was, said Cocteau, the 'greatest encounter of my life':[7] he always felt 'an electrical charge' in his company. Cocteau brought Diaghilev to

Picasso's drawing of
Serge Diaghilev,
c. 1919.

Picasso's studio, and this was the origin of their work together on
various ballets for Diaghilev's superbly opulent Ballets Russes,
which had first come to Paris in 1909 and then again in 1910.
'I never saw anything so beautiful', said Proust about Nijinsky's
death throes in *Scheherezade*[8] – clearly, Proust and Picasso had dif-
ferent points of view about the topic of mortality. Other popular
spectacles were *Le Spectre de la rose, La Péri,* Reynaldo Hahn's
Le Dieu bleu, and, of course, Nijinksy's famous role in Debussy's
L'Après-midi d'un faune, about which the long poem's author,
Stéphane Mallarmé, said to Debussy that he had already written
it in music.

Once Cocteau had persuaded the painter to accompany him to Rome to work with Diaghilev and the Ballets Russes, he was well on the way to being a lifetime friend – which he indeed became. Cocteau never lost his affection for or attraction to Picasso, and many of his letters speak of his excitement over 'our work together'. There is picture after picture of the two of them at various political demonstrations and at a bullfight late in Picasso's life. The Surrealists had little love for Cocteau, but Picasso was a free agent, and not bound, as the 'minor' Surrealists were, by anyone's dictates, affections or disaffections.

So, to resume the story. In 1917 Cocteau and Picasso, after visiting Gertrude Stein (who recounts the visit of the two of them, the elegant young Cocteau draped over the shoulder of her painter friend), left for Rome to join Diaghilev and work on the ballet *Parade*, for which Picasso designed costumes and sets (now in Museum of Modern Art, New York); Erik Satie wrote the music, and Cocteau the script, which deals with an avant-garde theatre troupe trying to capture the attention of an oblivious public by a fanciful parade. The lovely and fascinating Misia Sert was the constant companion of Diaghilev, and had introduced him to Satie. But she wanted to think, says Cocteau, that *Parade* was her idea. What a bitch, said Satie of Misia, but then, there was not much love lost between any of the persons circling about Picasso at this time.

Many commentators bemoaned the appearance of Picasso's having opted out of the avant-garde adventure by capitulating to the desires of Diaghilev, with his spectacular presentations for the bourgeois culture adepts. Cocteau makes fun of this attitude, declaring that, for the Cubists, the only possible trip was on the Paris Métro, from north to south (Montmartre to Montparnasse, a voyage to the capital importance of which Reverdy's Cubist journal called *Nord–Sud* bore sufficient witness). In any case, the costumes of the Managers in *Parade* are Cubist in feeling, to the point that Alfred Barr found there to be a 'Cubist domination' of the spectacle,

Picasso's costume for the 'American Manager' in Erik Satie's ballet of 1917, *Parade*.

the dancers looking so very small alongside the giant cardboard constructions. Yes indeed, but Picasso's design for the curtain, visible before the sets, was nothing if not neo-Classical: Harlequins from the *commedia dell'arte*, two women in shepherdess costume, and so on, entertained by a circus group – Latinate in feeling, and based in fact on a drawing of a *Taverna* by the Neapolitan genre painter Achille Vianelli, a reproduction of which Picasso had picked up in Naples, as well as on various works by Watteau. But Cocteau had miscalculated the atmosphere that Apollinaire had called that of a 'new spirit' ('l'esprit nouveau'), speaking of *Parade* as an example of 'sur-realism', by which he seems to have meant a kind of French classicizing and control. (Just before his death in 1918, Apollinaire was still encouraging his friend Picasso to make

large classically French paintings, like Poussin – indeed, Picasso's neo-Classical figures respond to just that impulse.)

When Picasso sent postcards from Rome to Apollinaire, Blaise Cendrars, a close friend, had kept up with his news. Here he is in March or April 1917, full of intellectual energy in his, and everyone's, beloved Paris, sending the painter a newsletter of sorts:

> Nord–Sud [presumably the subway as well as the journal bearing its name, so, *Nord–Sud*] comes and goes, between Montparno and Montmartre, they are celebrating Verlaine's BiCentenary at no. 200 Boul. St Germain and they are dressing themselves up at the Café de Flore with a mortal crown of a head of beer. Apollinaire has 'Tuesdays' at the Flore. Down with cubism they say. Long live cubism. Long live the idiots! The alexandrines![9]

Igor Stravinsky, 1920, pencil and charcoal on paper.

Olga Picasso in an Armchair, 1917, oil on canvas.

During his eight weeks in Rome, Picasso had a studio on the Via Margutta, and saw, of course, a great deal of Diaghilev, Léonide Massine, Igor Stravinsky and Léon Bakst. With Stravinsky, he visited museums, and with Olga Koklova, one of the dancers, he fell in love. Stravinsky, on first meeting Picasso in Rome, declared: 'I immediately liked his flat, unenthusiastic manner of speaking, and his Spanish way of accenting each syllable: "He ne suis pas musicien; he ne comprends rien dans la musique", all said as though he couldn't care less.'[10]

Writing to Picasso when the painter was staying in the Hôtel Russe in Rome, Cocteau complained of his glacial apartment, completely without heat; in his pink pyjamas and eating his plum jam,

he wrote about missing the kind of dream Diaghilev could create. He loved to recount the favourable reviews of the ballet *Parade*, on which he and Picasso had worked, and to keep his friend abreast of events and their mutual friends.

> I'm about to go see Apollinaire, perhaps he has acquired that equilibrium I need, which you possess and because of which I love you so tenderly. It's very simple to go far and rapidly with a fiery horse, the hard thing is to take wisdom to the extreme limits of daring.[11]

Over time, all sorts of complications arose, as might be expected from the 'evil manipulations and machinations' on the part of those whom Cocteau called Diaghilev's 'Jewish acolytes', and this mixed well with his emotionalism. Cocteau envisaged a kind of justice that would be a recompense for himself and Picasso, that is, the artistic temperament, whereas it would furnish a perfect hell for 'American managerism'. Apollinaire will help us, he says to Picasso, because of his enthusiasm about the realistic elements in *Parade* and about its theme. To his personal taste, he found the orchestration by Erik Satie a MASTERPIECE, but thought that Diaghilev and the composer Ansermet might find it 'empty, idiotic and vulgar'.

Cocteau took everything personally.

> If Diaghilev knew what *Parade* represents for me, on what level I consider it and what our sojourn in Rome meant, etc. etc., he would understand the sugary savagery of his work and would die on the spot. Poor guy![12]

Picasso had done a lithograph as the preface to the poems of Cocteau's lover, Raymond Radiguet, with the publisher NRF. And, in a sort of exchange, Cocteau was supposed to write a preface to Picasso's book at the publisher Stock. But oh, how he hesitated: 'To

speak of you! Without literature and without speaking about what doesn't concern me. Just a new conception. Give me some courage! Write me quickly!' And, by September, Cocteau was well along with his work. His attitude towards his writing was to keep it pure from framework, from any tinge of scholasticism or pedantry. 'I refuse to mix into my study the least biographical notice. I am just giving that date and nothing more.'[13]

Cocteau never wavered in his admiration for Picasso. How wonderful the pictures of you are, said the great flatterer: so photogenic, so magnificent, so worthy of your royal being. In Barcelona, Cocteau visited Picasso's family, where he found his sister like a queen also. Obviously, the whole image of the court was appealing to this courtier, who loved to arrange things such as Flamenco dances for the Spaniard. (According to John Richardson, it was after Max Jacob's fall from favour, owing to his disgraceful comportment on the way to Eva's funeral, that so disgusted Picasso that he made Jean Cocteau his official 'court jester'.)

And Cocteau's whole language fits into that mode, addressing Picasso as 'Cher Magnifique', 'Cher Seigneur', 'Cher Maestro' or 'Maestro chéri'. For example, in a letter of 3 February 1954, about one of the photomontages made by the photographer Jean Harold, whose studio was at 8 avenue Lamarck (and who portrayed Picasso as Velázquez's Infanta, or as the Pope – so convincing, said Cocteau, that I can see the white smoke rising to confirm it – and a number of other improbable guises, the more improbable the better), he wrote: 'Any time your genius expresses itself at any level, give me a small thought.' He actually wrote of wanting to kiss the walls of a museum exhibiting the painter.

Cocteau was, at least, unswerving in his devotion, whereas Picasso in various costumes, in various sets, was always clearly delighting in being various – in the same spirit as his shifting of painting styles. With Clive Bell, he enjoyed dressing up as a Spanish dancer (a photograph taken by Clive's friend Barbara Bagenal in

1959 bears comic witness to this), and with others, as other forms of being. Cocteau, with his own dramatic sense, clearly loved picturing men as disguised: he sent Picasso a picture of Freud with a fan, looking at a dancer, and was especially taken by an image of his lover Jean Marais as a bull. The notion of court and of bullring seemed particularly suited to each other, but a bullfight without Picasso and without Jacqueline, says Cocteau of one to which he went with Douglas Cooper, even dressed in his houndstooth best, would always be mournful.[14]

As for Cocteau, he has provoked great feeling on both sides of the coin over the years since his death, as he always did when he was living. As Elisabeth Cowling puts it, 'Jean Cocteau aroused love and loathing, admiration and contempt, in equal measure during his lifetime, and remains a deeply controversial figure to this day.'[15] There was a feeling of personal cult about him, exactly as there was with Picasso. As Jacques-Emile Blanche, the painter, wrote to his friend Paul Morand:

> Cocteau has periods. He is cyclic. I remember the Anna de Noailles phase six years ago: Jean talked about her so much that we, who all loved her, couldn't bear to hear her name! Today it's the Picasso phase. I have seen friends of Picasso in Barcelona. And know a good deal about him. He's a clever fellow at making use of people, for all his blunt air of a Montmartre bohemian. He has made use of Cocteau.[16]

But, of course, the truth is that they made great and good use of each other.

Much was done in Paris, as always, through personal intervention. As Cocteau had brought Diaghilev to Picasso's studio, Picasso brought the composer Erik Satie, the poet Blaise Cendrars and the Princesse de Polignac to Gertrude Stein, always an admirer and a support. (One day, Marcel Proust called on Stein when she was

unpacking Picasso's Cubist paintings and described them as 'touched by art as if by heavenly grace . . . apartments filled with cubist paintings, while a cubist painter lived only for them, and they lived only for him'.)[17] Proust greatly admired Picasso, comparing his work to the celebrated cave paintings of France, and, in his preface to Jacques-Emile Blanche's *De David à Degas*, speaking of 'the grand and admirable Picasso'.[18]

In 1916 Apollinaire published *Le Poète assassiné*, in which Picasso is the model for the artist, 'the Bird of Benin', about a poet who dies and an artist 'sculpts him a profound statue out of nothing, like poetry and glory'. A banquet in that year celebrated him, and was reminiscent of the banquet for the Douanier Rousseau that Fernande and Picasso had prepared in 1908. Picasso was often at the centre of such gettings-together, gathering friends about him as he had in the *tertulias* at Els Quatre Gats, managing meetings (and sometimes marriages), and in general being the centre of the social equivalent of an artistic *assemblage*.

He could deal with society whenever he chose. The rich sponsors of the Ballets Russes, such as Count Etienne de Beaumont, were very fond of *tableaux vivants*, as was high society in general. The point was that they thought of these tableaux, as of various forms of mythology, as being a 'universal alphabet', the only one that translated the human being in simple terms understood by everyone. But *Parade* was very different, the wildly divergent parts of his enormous cardboard figures sticking out in every direction, a brilliant combination of painting and sculpture – rather like a Frank Gehry construction of 1917. As Richardson puts it, 'The way Picasso plays cubist elements off against figurative ones generates much of the energy in *Parade*.'[19] In any case, the costumes of the Managers in *Parade* are Cubist in feeling, to the point that Alfred Barr found there to be a 'Cubist domination' of the spectacle, the dancers looking so very small alongside the giant cardboard constructions. And as for the set, Cocteau remarked: 'Before Picasso,

the décor had no part in the play; it was simply there.'[20] So much for Picasso's desertion of the avant-garde: his work with Diaghilev remained totally his, and in no case did the bourgeois audience at the Ballets Russes influence his own taste, changing though it was. (Olga's temperament and chosen style of living were another matter – but that would not last.)

The spectacle opened, in 1917, at the Théâtre du Châtelet, with programme notes by Apollinaire, lauding its super-realism (the fully acknowledged origin of the term *surrealism* as an appellation). The audience, scandalized (an easy thing in conventional Paris at that point), began whistling and booing, shouting 'Sales Boches' (presumably because of Picasso's relation to his dealer Kahnweiler and other German friends), until Picasso fled his box and Apollinaire stood up, his head bandaged from his trepanning, and they fell silent. (When *Parade* was re-presented in 1921, the audience cheered.)[21] Afterwards, the Ballets Russes performed in Madrid and, next, in June, in Barcelona, at the Teatro del Liceo, to great acclaim. At this point, Picasso had followed the Ballet, to be with Olga. In Barcelona he was given a homecoming celebration, prepared by Miguel Utrillo and others. The Ballets Russes returned to Barcelona in November, where this time *Parade* was poorly received.

Now, with Olga, who loved society and all that went with it, Picasso began to move about in the *haut-monde* of Paris, frequenting dinner parties, wearing formal dress and the like. Of this and of the theatrical world, Picasso would eventually tire: it was one of his roles, like many others. Speaking of this period, and the 'stiflingly respectable' Olga, John Richardson recalls the

> *embourgeoisement* brought about by marriage to a woman who, besides being silly and irredeemably square, was infatuated and jealous to the point of insanity . . . Just as Picasso's love for his wife paralleled his adoption of neoclassicism, so did his hatred of her parallel his rejection of it.[22]

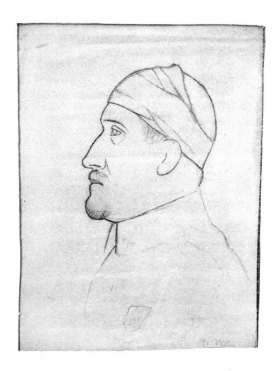

*Guillaume
Apollinaire
Wounded*, 1916,
pencil on paper.

He 'would love her passionately and possessively for a time and
then, in his misogynistic way, love to hate'. So Picasso left behind
him that style, that person, and, for a while, that genre of work.

The year 1918 was one of marriages. For Apollinaire's marriage
to Jacqueline Kolb, Picasso and Vollard were his witnesses, and
when, on 12 July, Picasso married Olga at the Russian Orthodox
church on the rue Daru in Paris, Apollinaire, Cocteau and Max
Jacob were the witnesses, and held crowns over Picasso and Olga at
the St Alexander-Nevsky Cathedral. For their honeymoon, the
couple stayed at Mme Errazuriz's home in Biarritz, la Mimoseraie.
Picasso had met her through Cocteau, and it was at her house that
he met his dealers, Léonce and Paul Rosenberg. She was part of the
circle of Misia Sert, the Comte de Beaumont and the Princess of

Polignac, and a friend of Igor Stravinsky, Artur Rubenstein and Blaise Cendrars. Her social graces and great generosity smoothed many feathers ruffled by competition, and she was especially fond of Picasso, whom she helped many times. Alas, after 1930, she remained alone, in a difficult financial situation, so that she – like Max Jacob and others – had to sell the works Picasso had given her.

In mid-November, Picasso and Olga moved from their flat on the boulevard Clichy, which Kahnweiler had found for them, to 23 rue La Boétie, which Paul Rosenberg found for them. Picasso had had to change dealers, because Kahnweiler, a German national, who was in Italy when the war broke out, could not return to France. The contents of his Paris gallery having been sequestered, he was unable to pay Picasso for his last paintings, which enraged the painter; the debt was not cleared until 1923. Rosenberg was Picasso's new dealer, from his gallery next door. Here, in the rue La Boétie, Picasso's studio on an upper floor remained his refuge. It was entered only by a very few friends, those worthy of having been to the Bateau-Lavoir, whether they had or had not been there in fact. The famous drawing of the drawing room there, with, as Patrick O'Brian describes it, Jean Cocteau, Erik Satie and Clive Bell, all 'wearing spats and sitting prim, polite, and uneasy in chairs poised on the edge of a curious deep step in the drawing-room', gives no sign at all of the presence of Picasso, nothing except a fiddle on the wall reflected in the looking glass, 'not a single heap of filth anywhere in that neat, comfortless apartment'.[23]

Also in November, Apollinaire, always Picasso's most revered friend, who had written the catalogue essay for the famous Matisse-Picasso exhibition at the Galerie Paul Guillaume at 118 rue La Boétie, was hospitalized with Spanish influenza. He died two days before the Armistice, a death that hit many writers, poets and painters very hard indeed. Apollinaire was rarely absent from Picasso's mind, and even on the painter's deathbed he was conversing with this greatest of Cubist poets. Apollinaire himself was famous precisely

for his 'conversation poems', like 'Lundi rue Christine', simply the transcription of words overheard.

The conversation, often implicit, between Picasso and Apollinaire always seems to have been a serious one, which was not always the case with Picasso, who never stopped calling on the figures of the *commedia dell'arte* tradition, like Pierrot and the Harlequin. They had appeared long before, in his early work, and reappeared now, which leads us to think, perhaps, that Picasso remained at a certain distance from his social role – always a player. Harlequin is equidistant between death and life, and wears a pieced-together outfit that links him, however loosely, to many traditions and times and customs, and, of course, to collage. Perfect for Picasso, always shifting, always changing. Already in his youth at Els Quatre Gats, he had been fascinated with the popular theatre. So this was a return to his roots.

When Stravinsky's *Renard* was performed, on 18 May 1922, the Sydney Schiffs held a reception at the Majestic after the performance, at which Picasso met Proust and Joyce, without, so goes the story, anything of particular interest being said. Or rather, it was a meeting of incomprehension. For Joyce could not see any special talent in Proust, and Proust is said to have said: 'I regret I do not know Monsieur Joyce's work.' Schiff even suggested to Proust that Picasso do his portrait, 'Only a drawing – it will take an hour.'[24] On the other hand, Proust was famously overcome with delight and a kind of exaltation at the spectacle of the Ballets Russes presentations, especially over the dancing of Nijinsky, no surprise there. But Proust's attitude to Picasso was entirely different. Writing to Walter Berry in 1917, he compared prehistoric cave paintings to the art of Picasso, and later, writing to his friend Jacques-Emile Blanche, author of the book *De David à Degas*, called him 'the great and admirable Picasso', who 'had concentrated all Cocteau's features into a portrait of such noble rigidity that when I contemplate it, even the most enchanting Carpaccios in Venice tend to take a second place in my memory'.[25]

In 1919 Cocteau published his 'Ode à Picasso', not the subtlest of homages, and Blaise Cendrars published his essay of farewell to Cubism: 'Pourquoi le cube s'effrite' ('Why the cube is disintegrating'). Picasso left for London to design the fanciful sets and costumes of *Le Tricorne* for the Ballets Russes presentation in the Alhambra Theatre there, which was choreographed by Massine and given a musical score by Manuel de Falla, from the novel by Pedro de Alarcón: *El Sombrero de tres picos* (the three-cornered hat). He designed a scene of *arrastre* (the removal of the dead bull from the ring) seen from a box with spectators, a couple on the left, three women on the right, with an orange-seller in the centre and, in the foreground, a bottle of sherry. Very Spanish. Picasso also prepared the frontispiece for Louis Aragon's *Feu de joie* (bonfire), a collection of Surrealist poems, published at Au Sans Pareil in Paris in 1920. With Olga he went to Saint-Raphael, loving always to take vacations by the sea, which he did every year, no matter with what woman or women he was involved, or what child or children were around. That year of 1919 he also designed sets and costumes for *Pulcinella*, a new ballet. To Picasso's surprise, Diaghilev rejected the first sketches as 'too modern', and so Picasso, usually willing to be flexible about such matters, revised them slightly.

On 18 January 1920 the Dadaist Tristan Tzara (Sami Rosenstock) arrived from Switzerland. There were Dada manifestations in Paris, and *Littérature* published poems by Tzara as well as by Max Jacob, Aragon, Cocteau and Breton, the future leader of Surrealism. Picasso had invited Max Jacob to a performance of *Tricorne*, but Max was hit by a car and, after one hospital visit by Picasso, they had little further contact for the next few years. The tie that had been strained at the funeral of Picasso's beloved Eva was strained even more, and, given Picasso's superstitious nature, we should not be as surprised as we might have been been. He was so constantly afraid of the very mention or exhibition of anything connected with death that he avoided both. One of the explanations of his placing the head of

Dora Maar on the memorial statue to Guillaume Apollinaire, as far-fetched as it seems, is that he feared doing anything actually to memorialize even his great friend. He had once, true enough, constructed a sculpted memorial to his friend the poet, but it was never built. Everything concerning the topic was disturbing to Picasso. So he continued his involvement with the *commedia dell'arte* figures Pierrot and Harlequin – both of whom represented a kind of living rather than dying – and with mythological subjects, and went with Olga to to the relatively joyous Juan-les-Pins on the Riviera for the summer, and, as always, returned to Paris in September.

For a show of Picasso's works in 1921 at the Leicester Galleries in London, the British art critic Clive Bell, who had previously said he was left cold by Picasso's works, now changed his tune completely, and said that indeed Picasso was the leader of the modern movement. In fact, reports Patrick O'Brian, at one point, Bell declared:

> Two people I have known from whom there emanated simply and unmistakably a sense of genius: one is Picasso . . . It has been my fortune to be friends with a number of very clever people: Maynard Keynes, the cleverest man I ever met, Roger Fry, Lytton Strachey, Raymond Mortimer, Jean Cocteau. None of them cast the peculiar spell I am trying to characterise. The difference between these very clever people and those less clever, between Roger and me for instance, was it seemed one of degree rather than kind . . . but Virginia [Woolf] and Picasso belonged to another order of beings; they were of a species distinct from the common; their mental processes were different from ours; they arrived at conclusions by ways to us unknown.[26]

Already in 1911 Clive and his wife, the painter Vanessa Bell, had purchased Picasso's still-life of 1907, *Pitcher, Bowl and Lemon* (whereabouts unknown), of which Vanessa made a copy for Charleston Farmhouse when the actual painting was sold to a dealer, and, by

1919, had been seeing a great deal of Picasso. When Picasso came with the Ballets Russes to London, Clive, Maynard Keynes and Duncan Grant gave Picasso and his wife Olga a splendid banquet at 46 Gordon Square, for about forty people. As Clive told it, 'Maynard, Duncan Grant, our two maids and I waited on them . . . We rigged up a couple of long tables: at the end of one we put Ansermet [the composer], at the end of the other Lytton Strachey, so that their beards might wag in unison.'[27] Picasso had felt free to ask Clive to do favours for him in England, such as introducing the Barcelona painter Ricardo Canals, whom he had known at Els Quatre Gats and who now lived in Paris, to the art world in London, and guiding him around. That letter of request of 25 February 1920 ends: 'When are you coming back to Paris? We are waiting for you.'

When Clive was in Paris, he would often send Picasso a *petit bleu* – those small messages transported by pneumatic tubes – about dropping in or coming to dinner. Occasionally, Clive was hesitant: writing in 1920 about how he gets to Picasso's stairs and doesn't want to bother him, he explains that 'to visit a great artist in the daytime really means my supposing that an hour of my chitchat is worth an hour of his work. You just cannot imagine how this intimidates me.' And he reiterates about 'the impertinent exchange' he was about to set up, that it would be 'one hour of my company for one hour of your work'.[28] But, as the bridge between Bloomsbury and Picasso, he could tell the latter how very much his wife Vanessa and the painter she loved, Duncan Grant, appreciated *Parade*, and he could suggest that his mistress Mary Hutchinson might pose for him.[29] In later years, he would go to see Picasso in the south of France, with Barbara Bagenal.

Indeed, the leader of the modern movement needed solitude, as he had said. His requirement for real work was just that: to some extent, this explains his treatment of the women in his life and the others – the poets he loved needed that solitude themselves, so they understood. The high society in which he had to move, during the

time with Olga, provided exactly the opposite. The Beaumonts, who had known him earlier, through Cocteau and with Gerald and Sara Murphy, in a fast jet-set crowd in 1923, wrote in 1948 to ask discreetly whether Picasso would ever wish to see them again. Picasso, who changed so and shifted so, was part and not part of that world, which was definitely different from solitude. He needed both.

From London, after the death of his lover Raymond Radiguet in 1923, Cocteau wrote that during the most difficult of days he had been thinking of Picasso as the person who had been the best example, and who had given him 'reasons to live after the worst pain'. And again, 'Picasso, you are life itself. If I could only see you, I'd be better.'[30] Over and over, Cocteau relied on Picasso, as so many did. And, with his psychological obsessions about gossip, he was easily alarmed about affections. He anguished over Picabia's having invented a story about Picasso's not loving him.

> Now I have measured the crumbling of my entire friendship for you! I had thought nothing would ever harm that, but . . . those cruel words. You who never speak of anyone, you spoke of me, who adore you, who would have died for you. Without Mother, I would have hurled myself from the window.[31]

And he begged Picasso to send a line to the editor of *L'Intransigeant*:

DEHORS CHAGRIN AFFREUX RESSENTI CE SOIR DOMMAGE UNIVERSEL
RESULTERA POUR MOI TE CONTRE RECTIFIER UN UNE LIGNE A DIVOIRE
INTRANSIGEANT *BIEN QUE CE NE SOIT PAS DANS TES HABITUDES FAIS*
LE POUR PRESERVER NOTRE AMITIE AUX YEUX DE TOUS JE SUPPLIE – JEAN

Besides the atrocious pain felt tonight a cosmic harm will come for me I beg you to rectify in just one line to the director of 'the intransigeant' although this isn't your habitual behaviour do it to preserve our friendship in everyone's eyes I beg you – Jean[32]

Any misunderstandings between the two of them Cocteau attributes to the ignoble Gertrude, and any patching up to his affection for Picasso 'the marvellous'. When he was with Jean Marais, the successor to Radiguet, he was happy again, remembering, now in 1944 at the age of 50, with his beard prospering, the time when he would always bring Christmas ornaments and trees to the rue La Boétie. Always Picasso leaves a mark, says Cocteau. Paris belongs to you, your signature is everywhere! And in December 1928, from a hospital in Joinville, far from anyone, trying to get over his opium habit, and longing for a communication from Picasso, he laments not having been part of the Cubist adventure of 1912. 'You know I was worthy of living near you. Here in this asylum am I: just please give me a sign of some sort!'[33] With Picasso, he has always been happy, for Picasso has 'broken all the pottery in the world and put it on the table with his own, making them all divine': halos seem to surround each of them.

The problem of Picasso's not writing was frequently cause for lamentation among Picasso's friends of all sorts, even though each of them was perfectly aware of his hating to write. His personal and genuine warmth in no way ensured any written communication – which, ironically, provoked from his correspondents still more letters. Only Apollinaire seems to have written fewer letters to Picasso than the latter to him – these were really the two equal partners in the adventure of Cubism and of the avant-garde at the beginning of the twentieth century.

7

Surrealism

I never do a painting as a work of art. All of them are researches.
I search incessantly.[1]

André Breton had already discovered Picasso's painting in 1917,
and pinned up reproductions on his walls in the Val-de-Grâce hos-
pital. Breton – who had been part of the Dada movement, when
Tzara moved to Paris from Zurich, where it had begun – was now
rapidly becoming the leader of the incipient Surrealist movement.
Convinced, as he was from the start, of Picasso's genius – after all,
he had persuaded Jacques Doucet to buy *Les Demoiselles d'Avignon*
and had reproduced it for the first time in the fourth issue of *La
Révolution surréaliste* – he was more than eager to have him join the
Surrealist ranks. Picasso never joined them, but neither did he
refuse what Breton asked of him, and it was at a Surrealist exhibi-
tion, at the Galerie Pierre in 1926, that he permitted, for the first
time, his works to be shown alongside those of other artists.

In 1922 Picasso spent June in Dinard, with Olga and Paulo, their
son, capturing the idea of the classic largish woman on the beach,
like a monumental discovery. *Woman Resting on the Beach* would
inspire other monumental figures. It makes absolutely the opposite
impression from the frightening work called *The Embrace*, painted
in Juan-les-Pins in 1925, with a kiss that looks more like a bite taken
out of the loved one's throat: this was exhibited in *La Peinture
surréaliste* at the Galerie Pierre in 1926. Its violence was in no way

André Breton, in an undated photograph.

anathema to the Surrealist programme, and indeed formed part of the programme against bourgeois institutions and conceptions. This year was also the one in which Picasso illustrated the famously homosexual and no less famously handsome Raymond Radiguet's colourful novel *Les joues en feu* and Pierre Reverdy's far quieter *Ecumes de mer*. In each, as was his habit, he did a portrait drawing of the author.

These drawings of writers, continuing for his lifetime, show Picasso at his most perceptive. In every case, in his portraits of poets and writers – Guillaume Apollinaire, André Breton, Jean Cocteau, Paul Eluard, Max Jacob, Raymond Radiguet, Pierre Reverdy, and

the group portrait of Cocteau and Clive Bell and others at the rue La Boétie – the line drawing reveals the man, just as the paintings of women, and, in many cases, the model for the *Painter and his Model* series, tell us exactly which woman is present, from Fernande through Eva, Olga, Marie-Thérèse, Dora, Françoise, Geneviève and Jacqueline. Whether the work is a line drawing having the delicacy of an Ingres, so important to Picasso (and many of Picasso's works were compared to those of Ingres in the exhibition *Picasso / Ingres*, held at the Musée Picasso in 2004), or is a radiant fleshly celebration of the earthy, or indeed any other style, a Picasso is generally recognizable – and so is its origin – in the massive forms and monumentality of classical sculpture. Picasso's work is all so intense that it could scarcely have failed to impress Breton as the very model of what he wanted Surrealism to be and to convey – at the outer limits of possibility.

Although Picasso permitted his works to be presented by the Surrealists in their exhibitions, he was never one for following movements or obeying programmes. Even if he had taken an interest in any movement, which was doubtful to say the least, given his originality and intense restlessness, he remained independent of this and every movement he had not created. Whereas he was the father of Cubism, along with Braque (and also the mother: 'I am Madame Braque', he is said to have said, visiting Braque in the hospital, and elsewhere, 'Braque is my wife', so in any case one of the parents), he was linked in no such way to Surrealism. He remained linked, in his mind, and in that of most of those who reflect on his art in its relation to his friends, to the time of the Bateau-Lavoir, and to Cubism.

Picasso's visual form of memoir, his painting of 1921, *Three Musicians* (Philadelphia Museum of Art), represents what Cocteau describes as a trinity: Picasso as the Father, Max as the Son and Guillaume as the Holy Ghost. Or then Max on the right as the monk, Apollinaire as Pierrot in the middle, and Picasso as the

Harlequin on the left.[2] It is in a sense a memorial for lost bohemian times, and friends, now that Apollinaire is dead and Max Jacob has retired to life in his monastery, and the 40-year-old Picasso is established in a bourgeois setting with Olga, who longed for a bourgeois life. Reff calls it an elegy for Picasso's 'lost bohemian youth, for freedom of the Bâteau-Lavoir days and the gaiety of Apollinaire and Jacob'. The counterpart to this painting is the *Three Women at the Spring*, which juxtaposes his modernist and traditionalist impulses. This is the true Picasso, displaying his personal choices:

> Where Picasso and Braque had attempted to create a group
> style of revolutionary impact by making almost identical paint-
> ings *c*. 1910–12 and agreeing not to sign their works, in the post-
> war years Picasso diametrically shifted the terms of his critical
> reception. Instead of presenting himself as one half of a revolu-
> tionary, pioneering team, he now appears as a lone artist with

multiple personæ. This is the Renaissance conception of a solitary, protean, overwhelming genius; Picasso in the 1920s becomes a modern Michelangelo.[3]

Picasso and his friends, Picasso and the 'bande à Picasso', Brassaï's *Picasso & Co.* – these are often the subject of reflection, of all the stories told about Picasso, looking back, and our own. As for memoirs, Max Jacob says of Fernande Olivier's book *Picasso et ses amis*, published in 1933 after much delay and over Picasso's strident objections, that it is 'the best mirror of the cubist Acropolis'. He quotes Fernande:

> Not so long ago, Picasso was thinking about Apollinaire and Max Jacob, whose name he is always invoking. He was wondering what they would have become, if they had gone on living; how they would have reacted to events. He thought about it intensely, trying, he said to have them traverse the years they did live, stopping at each major happening.[4]

Another major happening was the ballet *Mercure* in 1924, for which Picasso made the costumes and a decor with movable sets, Satie composed the music and Massine did the choreography. It was produced by the Count Etienne de Beaumont and Massine as part of a series of 'Les Soirées de Paris', at the Théâtre de la Cigale. But this benefit, announced as profiting Russian refugees, appeared to several Surrealists to be a benefit rather for the profit of an international aristocracy, and they protested. Breton and many others, however, signed a letter of apology in the *Paris-Journal* of 20 June 1924: the signers include the leading Surrealists Louis Aragon, Robert Desnos, Max Ernst, Max Morise, Pierre Naville, Benjamin Péret and Philippe Soupault, as well as the photographer André Boiffard, the playwright Roger Vitrac and the composer Francis Poulenc – quite a bunch of names – bearing witness to their

'profound and total admiration for Picasso, who defies consecration and goes on creating a troubling modernity at the highest level of expression'. So, just at the point when he had been accused of selling out to the establishment, the painter welcomed Surrealism's embrace. Aragon had said of Picasso's work, 'Symbolism, cubism, Dadaism are far in the past: *surrealism* is the order of the day', picking up on Apollinaire's original use of the term.

Repeatedly, Breton tried to interest the painter he so much admired in the meetings that were regularly taking place. To no avail, but the works were exhibited, first in the Galerie Pierre, and then his *papiers collés* at the Goemans Gallery, then at the Galerie Pierre, in 1935, with a catalogue written by Tristan Tzara. Picasso, in his turn, enjoyed illustrating the works of his friends, and did three etchings for Pierre Reverdy's *Cravates de chanvre* (woven neckties). In 1935 also, during a period when he was not painting, Picasso began writing 'automatic' poems like those of the Surrealists, at the suggestion of Breton, who published them in a special issue of *Cahiers d'Art* in 1936.[5] His poems, gathered in his *Ecrits*, feel as much like him as his paintings, to my way of seeing them. To Louis Parrot, he spoke about these poems, piled up in stacks:

> When I began to write them I wanted to prepare myself a palette of words, as if I were dealing with colours. All these words were weighed, filtered and appraised. I don't put much stock in spontaneous expressions of the unconscious and would be stupid to think that one can provoke them at will.[6]

In short, not a very Surrealist attitude.

But a closer look at his *Ecrits* gives another impression. Just as his sometime denegation of the importance of African sculpture for the *Demoiselles* is to be taken with a shakerful of Spanish salt, so too his off and on statements about his writing practice. In his effusive

Picasso with Michel Leiris, 1951.

and poetic essay in the *Writings* entitled 'Picasso the Writer, or Poetry Unhinged', Michel Leiris first quotes Picasso's inaugural poetic text: 'I can no longer bear this miracle, that of knowing nothing of this world and to have learned nothing but to love things and to eat them alive.'[7] What a grand miracle and what a strange one: this was the love that lasted, along with the liveliness of its objects and its subject.

Leiris points out how in the poems the present indicative prevails: 'The thing is here, right here, or is happening at this very moment.'[8] That is certainly the feeling projected from the painter's poems – immediacy. He thinks of the poetry as an interior monologue, a 'dance of language' more than of the objects referred

to, and a kind of date book, since Picasso inscribed the date on the text. Christine Piot's essay on his 'Practice of Writing' reveals that of all the prose poems, which were written in France between 1935 and 1959, most of those composed between 1941 and 1954 were in French, after which they revert to the bilingual French and Catalan with which they began. She mentions the celebrated detail about his collage 'Un coup de thé' sounding like a homage to the nine-teenth-century Symbolist poet Stéphane Mallarmé's 'coup de dés' – a fact also signalled by Rosalind Krauss in her *Picasso Papers*. This was not the only Mallarméan text that haunted Picasso, who also greatly appreciated Mallarmé's sonnet 'Le Tombeau d'Edgar Poe', with all its memories, bittersweet.

Tombs apart, it was not only Mallarmé that Picasso loved re-reading: there were Rimbaud and others. He recopied in 1905 a poem of Verlaine, which Max Jacob had read to him on his first arriving in Paris, as well as sonnets by Góngora (also the favourite poet of Robert Desnos the Surrealist), and in his own prose poems he referred frequently to Spain, in a kind of nostalgia. As for automatic writing and Surrealism – whose leader, Breton, so admired Picasso's poems, from their 'decantation' or stripped-down essence to their 'proliferation' and expansion, and whose imitation of madness, co-signed by Eluard, *L'Immaculée conception*, Picasso kept preciously as a manuscript – Picasso declared: 'Fundamentally, I have always written in the same manner. I have never stopped writing . . . My inner gift for automatic poetry – if you call it automatic poetry – has always been the same, in the thirties, before the thirties, and now'. But then he added, 'all Andalousians are a little Surrealist . . . such as Don Luis de Góngora y Argote!'.[9]

In *La Révolution surréaliste* (no. 6), one of Picasso's *Guitars* of 1926 is featured, and, four years later, Louis Aragon used two of them to illustrate his 'La Peinture au défi' (the challenge to painting), claim-ing that the collage practised by Dada and Surrealism, like a kind of

incantation, would put an end to painting. Rosalind Krauss points out the cruelty included in these guitars, with their nails, needles and barbed wire, reminding her of the violent perforations of Lucio Fontana's works in cloth.[10]

His life long, Picasso was besieged by requests from poets and writers to make illustrations for their works: for many he did portraits, for many he did other kinds of illustrations, and then for some he did nothing at all. Sometimes, as in the case of Antonin Artaud, Surrealist, genius and madman, the besiegers would come to beg at Picasso's studio, at 7 rue des Grands Augustins, which was to be from 1937 (until his eviction in 1967, after an absence of twelve years) Picasso's own living and painting quarters. The building had been found for Picasso by Dora Maar, who had known its attic when she was the companion of Georges Bataille, the founder of the political group Contre-attaque, which used to meet there. Picasso was all the more taken with the place since it was also the fictive location of Balzac's *Le Chef d'œuvre inconnu*. Picasso had illustrated and loved the story.

Antonin Artaud had known Picasso from the time when he was playing Tiresias in Cocteau's *Antigone*, for which Picasso was designing the sets. And Picasso gave one of his works to the Association des Amis de l'œuvre d'Antonin Artaud in 1946, to finance Artaud's stay in the asylum to which he had been committed. In his anguished letters to Picasso, Artaud begs him for a work to go with his poems, because that is the only way in which the publisher Bordas would print them. In a letter of 20 December 1946 he says he wanted to have this publication take place

> on ordinary paper at my request so that students and poets, the poor, the young without money, can also read them and not just the rich who profit from the black market, the North or South Americans and the lamas who haven't seen war for a hundred thousand years since the male vanquished the female,

etc. etc. This is to tell you that these poems are for me a call to what we still call conscience.[11]

A few days later, when Picasso has not answered, Artaud is angry:

I've already farted and sweated out my life in writings that are only worth the tortures from which they have come; but which are self-sufficient, and don't need any help or accompaniment from any person or thing in order to make their modest way . . . I've gone through nine years of internment, of molestations, cell, camisole, and five months of systematic poisoning with prussic acid and potassium cyanide, added to that, two years of electric shock, punctuated by fifteen comas, I've the scars of two knife attacks and the terrible sequels of the blow with the iron bar which in Dublin in September 1937, split my vertebral column, that's to say that in those conditions I have a hard time dragging my body around and that it isn't very friendly to have led me to drag my body five times from Ivry to the rue Grand Augustins . . . It can be that my poems don't interest you and you don't think I'm worth the effort but you should at least have told me and made the effort of making some response, whatever it was.

 This is a grave moment, Pablo Picasso[12]

Over and over Picasso was pressed by these and others, Surrealist and not, and often for financial help. Sometimes, as with Max Jacob or with Breton, he would offer a work of art that could be sold. But sometimes the actual money was necessary, for example, just to take the cases of two Surrealists, first George Malkine, to whom Picasso suggested that he restore himself in the country. Malkine asked him for money to buy cigarettes, in 1944, and then came a request: 'Can you help me one last and 3rd time?' and an anxious note, on 8 January 1945, 'Are you angry with me?

Or even not? I beg you not to judge me right now. For you, that isn't important. For me . . . well, can you imagine that I've been afraid of knowing you for 27 years.' And then he tells the following story from 1917, which reads like a conversion experience of the best kind. There is the feeling of awe that Picasso seems to have aroused so frequently. Friends had given Malkine a ticket to the ballet *Parade* at the Théâtre du Châtelet:

> Standing up, I was the first to shout and whistle my indignation. But I stayed. Then, I walked all night, only thinking about *Parade* and you . . . (I saw you walking along alone.) And your face, it was still more important than *Parade*. Never yet have I been wrong about a face.
>
> I went home. Unable to sleep, I burnt! – 'my' tragedy, all the models, everything I'd drawn, painted or written until then. And the next night I returned to the Châtelet, paying for my ticket. And I shouted my enthusiasm, delirous: it was my liberation. There it is. THE great turning point of my life . . .
>
> And then I went back to you, not realizing that I went as if I had counted in your experience for 27 years. My letters to you were crazy, I was feverish, and I wanted to explain that. But I couldn't see you when I tried. I hope you haven't written me off. But that isn't like you. But you could just have had enough, and that's something else.[13]

And then, in despair over not being able to see Picasso, Malkine returned to him the 3,000 francs he had lent him, on 7 December 1948.

The second case concerns Benjamin Péret, Breton's most faithful disciple, and one of the genuinely good-spirited poets. Péret couldn't get into America because of his left-wing politics, and so he went to Mexico. He wrote to Picasso in 1938, to help with his problems and those of his painter wife Remedios Varo, and again

in 1940, when she was translating and he had no means of paying the rent. Thanking Picasso in January for having instantly sent a cheque, he wrote: 'It removes a thorn like an arrow of the Sainte-Chapelle from my foot, or of the Eiffel Tower or something like that.' But then in the summer, when he had been imprisoned for subversive actions in the army, and when Remedios had no work, he asked once more for ransom money in order to get out, in June, 'May I ask you again?', and in July, 'I hate to bother you again . . . I have been imprisoned since 25 May. The Germans need a deposit of 1,000 francs.' Presumably, Picasso paid, and then in October of the next year, he asked yet again: 'I have no means of living'.[14] Picasso came through every time.

Another side of Surrealism is manifest in everything done by Salvador Dalí. His first contacts with Picasso and the first drawings and cards he sent to the painter date from 1927, and last until 1972, when he wrote to Notre-Dame-de-Vie in Mougins to say that he and his companion Gala (who called Picasso 'the king') would like to come by, as they often did together. Dalí approached Picasso as one Catalan to another, and often went by the studio to take a look.

In 1928, when he and Buñuel were finishing *Le Chien andalou* and taking a holiday by the sea in Saint-Valery-en-Caux, Dalí contacted Picasso to see when he could encounter him and his work. Breton had spoken enthusiastically to Dalí about Picasso's latest works, and he wanted to see them. Dalí was always overflowing with many things to speak to Picasso about, and whether he wrote to him from the seaside or from the 'terribly picturesque mountains' he wrote with a warmth and the enthusiastic style we recognize: ' I have so many *ideas* that it is difficult in the evenings to go to sleep – I think it's a question of pressure.' He recounts incidents such as the digging up of Antoni Gaudí's corpse in Barcelona: 'He looked anguished (which is natural, given his age) but he was pretty well conserved . . . The anarchists always know where to find "the pot with the good jam".'[15]

Dalí sent Picasso the printed *Declaration of the Independence of the Imagination and the Rights of Man to His Own Madness* (New York, 1939), and wrote to him about his exhibition problems, about 'certain New York department stores' altering his concepts, and, worse, some committee forbidding him to represent his work *The Dream of Venus*, that is, the image of a woman with the head of a fish. They told him that a woman with the tail of a fish is possible, but not the other way round; in short, they were negating the right of a free imagination. Had there been such a ban in ancient Greece, says Dalí to Picasso – one freely imagining Catalan to another –

the Greeks would never have created and therefore never would have handed down to us their sensational and truculently surre-alist mythology . . . in which there figures indisputably a Minotaur bearing the terribly realistic head of a bull . . . The public is always superior to the rubbish that is fed to it daily.[16]

Dalí, Magritte and Picasso had the same surrealizing creative spirit of invention, from fish-women to Minotaurs, a kind of Surrealist genius. Dalí addressed the artists and poets of America, warning against institutional censorship, 'If you wish to recover the sacred source of your own mythology and your own inspiration', and pro-claiming: 'It is man's right to love women with the ecstatic heads of fish.'[17]

In October 1949 Dalí thanked Picasso for what he too had done in the realm of art: 'Thank you, thank you, for having killed Bougereau and also, and above all, modern art in its entirety by your integral and categorical Iberian genius!'[18] Now, says Dalí, 'crazy with joy', we can start to paint original works of art. In 1956 Dalí was able to assure Picasso, who probably didn't need that reassurance, that he was painting 'real masterpieces, just the kind they were doing in Raphael's time . . . I embrace you and will come to show you again my paintings you will be crazy delighted.'[19] This

must have been a real relief for Picasso, as Dalí's thanks must have been. We can hear him laugh, just the way he did in Bateau-Lavoir times. The whole thing is Surrealism in its most delightfully over-the-top mode.

What often seems to the casual observer of Picasso as over the top is the galaxy of his female muses and models, legendary for their variety, their voluptuousness and often their violence of portrayal and feeling. Paul Eluard put it perfectly in saying, 'Picasso aime intensément, mais il tue ce qu'il aime' ('Picasso loves intensely, but he kills what he loves'). In 1927 the painter encountered the lovely Marie-Thérèse Walter, 17 years old, in front of the Galeries Lafayette in Paris. He addressed her with the irresistible words, 'I am Picasso. You and I are going to do great things together.'[20] For those acquainted with his memorable early statement in Barcelona: 'Yo soy Picasso', the echo is notable. This sufficed for his addition of Marie-Thérèse to his gallery of models – always ongoing in its openness to chance, encounter and new love. To keep Olga and Marie-Thérèse apart was a challenge to which he was certainly equal, as he was to the other like challenges in his life and art.

In May of that year, 1927, Juan Gris died, a loss more to the art world than to the man Picasso, whose relations with him, as we have seen, were not unstrained. And then, during the summer in Dinard with Olga and Paulo, Marie-Thérèse is also there just down the street, so that he has to juggle between the two – the interesting part of the story. (In Paris, Marie-Thérèse lived at 44 rue La Boétie, right down the street from his and Olga's apartment at no. 23. Same story: clearly he liked juggling between two women.) Krauss finds in this attraction to doubleness (which Françoise Gilot had also stressed) one of the structuring principles of his collages, a way of working out the system of formal oppositions that she finds at the very heart of painting, whose meaning they determine.[21]

After 1918 Picasso always spent his summers at seasides: Biarritz, Vannes, Juan-les-Pins, Cannes, Dinard. His various portraits

during the 1920s and '30s of *Baigneuses* (such as Marie-Thérèse in 1927), or his etching for Tristan's *l'Antitête*, for the Editions des Cahiers Libres, of *Three Graces on the Beach* (1921, later dated 1923 by the painter by mistake), says Pierre Daix, bear witness to his enthusiasm for female anatomy as it is displayed at the seaside.[22] Nor was this kind of painting devoid of an aspect of cruelty: one of the seaside paintings has a female mantis devouring her mate. The sand must have had its own appeal. Like André Masson's use of sand in his works of 1927, such as the *Battle of the Fishes* (Museum of Modern Art, New York), Picasso worked in sand reliefs during this period.

And he must have enjoyed getting away from the bustle of Paris, the same impulse that persuaded him to purchase Boisgeloup, 40 miles north-west of Paris, where, in the summer of 1932, he was visited by Braque, Leiris and their wives. *Nude in a Garden* (1934; Musée Picasso, Paris) is full of pink and green leaves, and the *Woman with Leaves*, painted on 4 August 1934 at Boisgeloup, carries the same joyous feeling. Picasso made textured sculptures in plaster forms – leaves, a box of matches, cardboard – in an outpouring of creative glee. In the etchings commissioned by Skira to illustrate Ovid's *Metamorphoses*, Marie-Thérèse is recognizable; these were published in 1931. (A wonderful recounting has it that each time he finished a plate for Skira, whose publishing house was next door on the rue La Boétie, he would lean out of the window with his trumpet to celebrate: never, says Skira, was he so happy at a signal.) Marie-Thérèse is clearly the model for the erotic engravings of the Vollard Suite, in such works as *The Sculptor*, where the artist is contemplating a bust of her; and in the women sleeping (*The Dream*, 1932; Collection Mr and Mrs Victor W. Ganz, New York) or or the *Girl before a Mirror* (Musée Picasso, Paris).

Marie-Thérèse represents the radiant side of Picasso's portraits of women, whether she is curled up in an armchair or stretched out somewhere. But much in Picasso's work and imagination is tinged

with dark. His split-up with Olga, whom he could not divorce because of the complicated divorce laws in France, occasioned her move to the Hôtel California with Paulo, while Marie Thérèse stayed with her mother. For Picasso, this year of 1935 was the worst time of his life, as he put it. Olga was trying to appropriate half his property; Marie-Thérèse was pregnant; and he was unable to paint – so he turned to prose poems, many of which Breton published in the *Cahiers d'Art*.

It was Breton who encouraged Picasso to write poetry, first during that terrible year of 1935, when everything was going wrong, a poetic practice he continued for a few years. Jaime Sabartès, himself a poet as well as Picasso's bridge to the world, recounts how at that period Picasso was doing nothing else, no painting, no drawing: they would sit up late at night, the two poets. Specific to Picasso's own practice of poetry is the litanic mode, which came instantly to him in his prose poems. Little wonder, since it was André Breton who initiated it, as in his most famous love poem, 'Union libre', which works to its supreme closure in a litanic fashion.[23] It is not hard to see the results in Picasso's own poetry . . .

In 1936, at the Café Deux Magots in Paris, Picasso had been introduced by Eluard to the photographer Dora Maar, a dark beauty – half-Yugoslav, half-French, who had been brought up in Argentina. She was stabbing a penknife between her fingers, and a little blood was spurting out from time to time on her black gloves with the pink roses on them. Picasso was, of course, intrigued by such exotic behaviour, remarked to Sabartès on Dora's beauty, and heard her respond in Spanish. To no one's particular surprise, they ended up together, and spent part of the next two summers with Eluard and Nusch (who was shared between the two men.)

One of Picasso's poetic eulogies of Dora Maar (for whom and with whom he wrote many of these poems) goes like this:

Her great thighs
her hips
her buttocks
her arms
her calves
her hands
her eyes
her cheeks
her hair
her nose
her throat
her tears
the planets the side curtains drawn and the transparent sky
 hidden behind the grill –
the oil lamps and the little bells of the sugared canaries
 between the figs
the milk bowl of feathers, snatched from every laugh
undressing the nude
from the weight of the arms taken away from the blooms of
 the vegetable garden
so many dead games hung from the branches of the meadow
 of the school pearled with song –
lake lured with blood and thistles
hollyhock played at gaming
needles of liquid shadow and bouquets of crystal algae open
 to dance steps
the moving colours shakers at the bottom of the spilled-out
 glass –
to the lilac mask dressed with rain[24]

This period, in which Picasso was closest to Surrealism, was
also the period of the Minotaur, a theme to become all-important
in Surrealism, and used for the title of the luxurious and magnifi-

cently illustrated publication *Minotaure*, the first issue of which was published on 1 June 1933. It replaced *Le Surréalisme au service de la Révolution*, which itself replaced *La Révolution surréaliste.* The bull is closely allied to Mithraic ritual and to the primitive worship of the sun discussed by Bataille in his 'Soleil pourri', in *Documents.* The spectacle of bullfights for Picasso the Spaniard, fascinated from child to old age by all the ceremony of them, had all that other ritual behind it. He was often accompanied to bullfights by Michel Leiris, the writer whose poetry so frequently recalls them. The religious element to the bullfight, in which the cruelty of the spectacle and the intensity of the performance place it, *toutes proportions gardées*, in the same realm as the Crucifixion, a likeness of which Picasso was well aware, as displayed in his *Guernica* and his *Charnel House.* 'J'ai une véritable passion pour les os', he would say ('I have a real passion for bones'). Thus the so-called bone style of his monuments of 1929, and the metamorphosis of a *Crucifixion* from the Isenheim altarpiece of Grünewald in Colmar, reproduced in the first issue of *Minotaure.* Picasso, who had denied Breton's affirmation of the Surrealist spirit in his guitars, authorized a link between him and Surrealism only in his drawings of 1933, 'Une anatomie', published in that first issue of *Minotaure*, for which he also supplied the cover, described by Brassai, in an outburst of high spirits:

> On a wooden plank, he had thumbtacked a section of crushed and pleated pasteboard similar to that he often used for his sculptures. On top of this he placed one of his engravings, representing the monster, and then grouped around it some lengths of ribbon, bits of silver paper lace, and also some rather faded artificial flowers, which he confided to me had come from an outmoded and discarded hat of Olga's.[25]

In his fulsome eulogy of the painter of 1933, 'Picasso in his Element', so often quoted, Breton stresses, like a *revolution* of vision,

what he sees as Picasso's *revelation*, refashioning the world in 'his own image' – and we observers are 'the object of a revelation'.[26] And yet, of course, as Tériade quotes him in an interview he did for *L'Intransigéant* (and published on 15 June 1932), Picasso said: 'There is not a painting or drawing of mine that does not exactly reproduce a vision of the world . . . my concern for exactness . . . One's work is sort of a diary . . . old canvases . . . seem like prodigal children – but they've come home wearing a shirt of gold'. So his art is not about invention, but about perception, being the records of that. From a modest, seemingly haphazard, throwing-together of a few highly disparate objects – nothing rich about them, nothing luxurious – an entire new world was created. In Breton's eulogy the description begins in a commonplace of utterance and utter simplicity: 'there is a common butterfly immobilized for ever near a dried leaf on the back of this page'. (Only in this work of 1933, says Breton, has a real butterfly entered the field of a painting as itself, not some kind of dried-up powder.) And then there comes about that magic occurrence, providing 'suddenly the kind of unique emotion which, when it grips us, provides unassailable evidence that we have just been granted a revelation'.[27] Precisely, the independence of Picasso's spirit is to be lauded: 'the marvelous *range* of a mind which has never obeyed anything but its own extreme tension'. For in this work of genius, only an interior determination counts. It never could have been that any exterior programme, such as that of the Surrealist group, could have had any effect on the progress of Picasso's own programme, in which all is self-determined: 'The radiant river . . . has offered itself some obstacle and has just swept it aside.'[28]

Breton's favourite image of the Surrealist aesthetic was originally based on Pierre Reverdy's Cubist programme of taking two elements from far distant fields and throwing down between them a connecting wire ('le fil conducteur'), with its metallic matter conducive to a flash like a lightning spark. This is itself linked not only to Eluard's 'donner à voir' (literally, to give to see or to give to have)

but to Picasso's own notion of connection: art should be like a bridge, he says. 'What would be the best bridge? Well, the one which could be reduced to a thread, a line, without anything left over; which fulfilled strictly its function of uniting two separated distances.'[29]

Picasso, for Breton and the other Surrealists, was the one who most surely bridged everything, uniting in some miraculous way the everyday marvellous and the radiance of the ongoing idea of encounter. Never mind that Picasso had no intention of adhering to whatever Surrealist doctrine was meant to be at a specific moment, or any enduring theory. He was beyond all that, as Breton pointed out in 'Picasso dans son élement', a chapter eventually gathered in *Le Surréalisme et la peinture* and all-important for what it says about his point of view towards his most admired painter:

> We claim him as one of ours, even though it is impossible – and would be impudent, furthermore – to apply to his means the rigorous critique that elsewhere we propose to institute. Surrealism, if one must assign it a line of moral conduct, has but to pass where Picasso has already passed, and where he will pass in the future.[30]

Breton had won Picasso's esteem in any case, during the *Soirée du coeur à barbe*, with a performance of Tzara's play *Coeur à gaz*, on 7 July 1923, a Dada event at the Théâtre Michel, with films by Man Ray and Hans Richter, and music by Darius Milhaud, Satie and Stravinsky. During the performance, Pierre de Massot had shouted an insult about the death of Cubism: 'Picasso dead on the field of battle!', at which point Breton leapt on the stage and broke Pierre de Massot's right arm to avenge Picasso. So then Picasso was to do a portrait of Breton for *Clair de Terre*, which he did, in a monumental style.

One of my favourite and most convincing passages has to do with an interchange between the admittedly prudish Breton and a

far-out canvas of his favourite painter, a smallish painting on which he sees 'a large impasted lump' representing, according to Picasso who has just put it there and tested whether it was dry, not just ordinary *merde*, or as Breton less colourfully puts it, *excrément*, like that children leave after digesting cherries with their seeds. Here is the great thing: Picasso is waiting for the flies to come and stick on the canvas, proving it is real shit (as it were), and Breton is suddenly granted a spanking new vision of a universe, excremental but gorgeous, into which he can venture. He thinks of those 'shiny brand-new flies. Everything suddenly seemed bright and gay . . . I plunged gladly into the woods.'[31]

Breton loved to visit Picasso in his studio. But there were often too many people, and on 29 September 1935 he wrote in a kind of desperation, hoping that there might be – despite the painter's now ever-more crowded schedule, his ever-more crowded studio – an hour in which Picasso would see him again: 'You know how much I admire you and how I dreamed, when I was young, of occupying a small place in your life. To be counted one day among your friends one day, that's what I was hoping.'[32] Sometimes, as here, on 16 March 1936, he feels jealous of Paul Eluard's spending so many evenings with Picasso. The painter was, said Breton, 'one of the two or three beings who make it worthwhile living'.[33]

In 1940 Breton and his family took refuge with other Surrealists at Mary Jane Gold's villa Air Bel near Marseille, and on 24 March 1941 they went to New York.[34] Surrealism flourished there, despite its leader's refusing to have anything to do with the language he saw as not his own. Upon Breton's return in 1946, he found everything changed, and all his friends seemed to be elsewhere. Picasso had joined the Communist Party in 1944 with Eluard as his sponsor; and Louis Aragon was the organizer of the Party. Breton seemed to be no longer in Picasso's circle, no longer part of the 'bande à Picasso'.

The break between the two men is recounted differently, but amounts to the same thing. In her memoir, Françoise Gilot tells of

looking out of the window at Antibes with Picasso in 1946 and seeing Breton below. Rushing down, Picasso held out his hand in greeting, only to have it refuscd by the Surrealist, who so greatly disapproved of his having joined the Communist party that he wished to have nothing further to do with him. And then Breton wrote the distressed and distressing piece called '80 carats . . . but a shadow', about losing his friend to the Party.[35] So much for history.

But what we have to remember about all this is, I think, that Breton was, from early on, able to understand, even to appreciate, 'the continuously dialectical progress of Picasso's thought'. Moreover, despite the personal feelings over political issues, Breton's admiration for the actual painting had no downside to it and never diminished. As an inventor more than a sticker-to-one-style, Picasso was always beyond the limits of any particular programme, be it Cubist, Surrealist or Communist. He was simply and absolutely Picasso. No strings attached.

A far more unlovely and unidealized Picasso is presented by another Surrealist, the fine writer of novels and essays and art criticism, Louis Aragon, whose *Henri Matisse, Roman*, and whose novel

Picasso and Louis Aragon, 1949.

about Courbet (*La Semaine sainte*) are both of them unquestioned masterpieces. Before Aragon had written his masterpiece – the extraordinary *Paysan de Paris* of 1924 – he had published in 1921 a brief *roman à clef* called *Anicet, ou le Panorama*. In that novel, Picasso, greatly admired by Aragon, but never as close to him as Breton or Eluard, is known as the Blue Painter, 'le peintre Bleu', because the book deals with a time when he was indeed that above all other things, and Max Jacob is known as 'Jean Chypre'. (Max Cyprien, Picasso, his godfather, had wanted to call him, when the name 'Fiacre' was found unusable.) Picasso, not always poor by any means, and not always generous either, is contemplating his friend Max Jacob, always poor and always generous. Here he speaks, as Aragon describes the encounter, to Max, whose bare face is 'quite simply celestial'. I make a rough transcription:

> I come to contemplate you, thinking of our sufferings, dear
> Poor one, and feel the delicious pity of this common past from
> which I alone have been able to escape. In my warm overcoat
> with its astrakhan collar, I come close to you, Jean the Miserable,
> my companion in my freezing youth, that winter without coal
> in that studio without furniture. Do admire the costly cigar that
> I'm about to light: we are only three in the world to smoke
> ones like these.

Before Picasso joined the Party in 1944, which he did to show his opposition to Franco and his political feelings, he and Aragon were never particularly friends. Their characters could not be more opposed. Breton's admiration for the painter went past those of the other Surrealists, and always his (in my view laudable) gift for admiration was present: like Marcel Duchamp, Breton's other greatly admired creator, Picasso was to be saluted for what he could and did create. When the political strain became too great, Breton moved away, in spite of his past affection.

Max Jacob, writing to Salmon on 25 October 1943, laments about all this:

> No one will ever be able to measure the harm the Surrealists did to Picasso. They have killed friendship in him, and God knows he was born for friendship. After a trivial conversation with Paul Eluard, he said to Picasso: 'One always has too many friends.' This is the Surrealist spirit falling heavily upon an ex-Surrealist. Here's the picture: they dried him up and finally abandoned him. He is very alone . . . His legitimate wife refuses to divorce him and continues making millions of debts that he has to pay. What a humiliation.[36]

On Picasso's side, there had never been for Breton the intense warmth of friendship he had felt for Max Jacob, Paul Eluard and, above all, Guillaume Apollinaire. And it was Apollinaire, after all, whose term 'surrealism' had ended up defining a movement, arguably the most significant one of the twentieth century.

8

Guernica and the Party

a symptom . . . so mingled with the net of coloured wires of a frequency more or less accelerated on the metronome of + or − sensational heat moving from well-being to pain force the forms of the floating crystals take in an overview of the canvas the direction wished for[1]

A terrible contrast was made to the idyllic times the Surrealists had spent together when the Nazi allies bombed Guernica, a small Basque town devastated by the forces of Franco, on market day, 26 April 1937, during the Spanish Civil War. It was the first case of the mass bombing of a civilian target. Picasso had already accepted to paint a mural for the Spanish pavilion at the International Exhibition of 1938 in Paris; and three weeks after the news of the bombardment was made public, he completed *Guernica*, an immense work that surely stands as the greatest political statement of the century, and, together with the *Demoiselles*, as the most evident manifestation of the power of modern art. His feelings about Franco were clear for anyone viewing his grim cartoonlike *Dream and Lie of Franco* (Wake Forest University, Print Collection), also of 1937.

Like all the great statements of past painting – and yet unlike them – *Guernica* makes its mark. Its *grisaille* matches that of the photographs on which it is based. Unforgettable, its bull and agonizing horse, its garish light bulbs, the fury of the sun and the sacrifice, and its anguished woman, known as 'La Femme qui

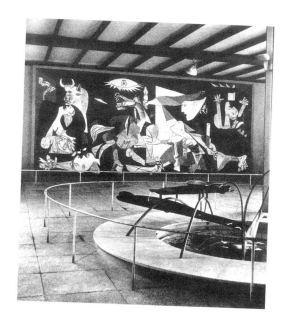

Picasso's *Guernica*, as installed in the Spanish Pavilion at the 1937 Paris World's Fair.

pleure', the weeping woman, usually identified with Dora Maar. Dora, in fact, painted the vertical hairs on the horse, photographed Picasso in all the stages of his work on this great and anguished painting, and spoke Spanish with him, a comfort in the terrible times of Franco's Spain. Christian Zervos, having saluted Picasso's prose poems in a preceding triple issue of his *Cahiers d'Art* (nos 7–10), now gave an account of the history and the photography of *Guernica* in his piece 'The Story of a Painting'.[2]

This was Picasso's response also to his fellow Spaniard Goya's dark reflections in his time on war in the *Third of May* (1814) appropriate for the short and dynamic painter often called 'little Goya'. Both these works of art captured the horror of war images: 'cries of children cries of women cries of birds cries of flowers . . . of stone . . . cries of furniture of beds of chairs of curtains of pots of cats of papers cries of odours', as in one of Picasso's prose poems from this moment.

Both the painting and the poem on Guernica written by Picasso's great friend Paul Eluard stand in parallel as humanistic and heartfelt protests against the pain and terror of a bellicose time. The poem begins with the good time and the good world, until the arrival of destruction, and ends with a hope of triumph after the disaster, hence the title 'Victory at Guernica':

> Lovely world of cottages
> Of mines and fields
>
> Faces good in the firelight good in frost
> Refusing the night the wounds and blows
>
> Faces good for everything
> Now the void fixes you
> Your death will serve as warning
>
> Death the heart turned over
>
> . . .
>
> Pariahs the death earth and ugliness
> Of our enemies have a colour
> Grim as our night
> We shall win out[3]

The hand stretched out in Picasso's *Guernica*, powerless but desperately desiring communication, plays no less a powerful role than the anguished faces and screaming horse.

At the close of the International Exhibition, *Guernica* was shown in Scandinavia, Britain and the United States as a testimony against Fascism, after which the painter wanted it kept in the Museum of Modern Art in New York until democracy was restored to Spain. When it was taken to Spain, in 1981, on the centenary of Picasso's birth, many New Yorkers, including this author, wore black armbands to lament its departure, even as we saluted the reason for its

return. It was really a salute to the painting and its power, and to the painter.

It was in the studio at 7 rue des Grands Augustins that *Guernica* was painted. A famous anecdote has it that Marie-Thérèse went there one day to visit Picasso when he was painting, and quarrelled with Dora, alleging that since she had had Picasso's child she was the one to have rights there, not Dora – a particularly painful allegation since Dora was, it was said, infertile. A hair-pulling and struggle ensued, which greatly delighted Picasso: what a fine time it was, he later said to Françoise Gilot, Dora's replacement, in 1942. Picasso was used, after all, to having two women on whom to bestow his favours, and it was up to them to work it out, or ignore the problem. They each had their different ways of dealing with it and him.

There were other visitors. Once, when the Gestapo came to inspect the studio, they pointed to the great painting and asked Picasso: 'You did this?' No, he said, 'you did'. Picasso and Léger were the only two non-Jewish painters prohibited from exhibiting their work during the Occupation. And it was, of course, difficult to procure materials with which to paint: Picasso's resourcefulness was useful here, so that he was able to use such unlikely things as bicycle handlebars in his sculptures (this for the bull's head).

In the south of France, things were – to some extent – different. In 1939 Dora and Picasso went to Antibes, by *le train bleu*, and rented an apartment from Man Ray. All was not of good cheer, however. In August 1939, by a terrible and strange happenstance, the dealer Ambroise Vollard, whom Picasso had always had a great deal of affection for, was killed in his car by one of Maillol's statues he was transporting – the irony was heavy, like the statue. Picasso rushed back to Paris for the funeral, and, later, went with Dora to Royan, on the Atlantic coast, near Bordeaux. During the war, when Breton was the head doctor in Poitiers, he often visited Picasso and Maar at Royan, who also welcomed Breton's wife Jacqueline and their little daughter, Aube. Breton would join them on his leaves from the hospital.

As for the friendship at that point between the painter and the poet, Picasso, well aware of Breton's difficult financial situation, had given him a painting to sell. They remained indeed close friends until Breton's inability, upon his return to France after the war, to comprehend Picasso's allegiance to the Communist party. He had had his own problems early on, when he had wanted to put Surrealism at the 'service of the revolution', as his journal had stated it, and was not altogether objective about political situations in general. But his testimonies to the small painter's great stature remain, and are, in the long run, what counts.

After *Guernica*, Dora Maar would paint her own effigy of the Weeping Woman as the *Weeping Woman Under a Red Lamp* (1937; Penrose Collection, London). Of all his mistresses and lovers, she was probably the most talented and definitely the most intellectual. But in 1942 she began to act strangely, and after various dramatic scenes bearing witness to her unsettled character – sitting naked on the steps, causing disturbances here and there – she was hospitalized, until Eluard was able, with the help of the psychoanalyst Jacques Lacan, to bring her home. She stayed under treatment with Lacan, and finally became a recluse in the south of France, in a house in Menerbes that Picasso had given her – although he and Françoise Gilot used it for a holiday, much to Dora's distress. Lacan said to those who enquired that he had had a choice for Dora of a straitjacket or the arms of the Church. She phrased it differently, but to the same effect: 'After Picasso, only God'. Little by little she retreated from the world, but not from painting – and not entirely from photography: her last assistant tells of bringing her, in Paris, a Polaroid instant camera, which she loved and worked with. And, in Menerbes, she was taking old negatives and collaging parsley and popcorn upon them: the images of André Breton and Lise Deharme (the lady with the glove, in Breton's mythology), doctored in this way, were shown at the Michelle Chomette Gallery in Paris in 2000.

In 1940 a large retrospective of Picasso's art opened at the Museum of Modern Art in New York. Organized by Alfred Barr, it included 344 works, including *Guernica*. That year also his *Vollard Suite* was published, dealing with the theme of the Studio.[4] He found a studio in Royan, on the fourth floor of Les Voiliers (the sailboats), overlooking the sea. In February he returned to Paris, and in March three of the Surrealists were mobilized: Breton, Eluard and Aragon. In May the Germans invaded Belgium, and Picasso returned to Royan with Dora. Then, in June, the Germans entered Paris; the Armistice was declared, and on 23 June the Germans entered Royan. Picasso returned to Paris in August, to live in his studio. He refused all the favours the Germans might have offered him, including heat: 'A Spaniard is never cold', he is said to have said. Maia and Marie-Thérèse returned to Paris, and lived on the boulevard Henri IV.

In 1942 Vlaminck attacked Picasso in the pages of *Commedia*: he was defended by André Lhote. Eluard joined the Communist Party, which Picasso would do two years later, to show, he said, his anti-Franco stance. To celebrate his joining, Picasso made a work to which he claimed a resemblance: *The Man with a Sheep*. There was a great commotion in the newspapers about Picasso's Party adherence. When, in April 2004, the Paris police files were opened, it turned out that the French police had spied on him during the 1930s and '40s, suspecting he was an anarchist. He had applied for French citizenship in 1940, fearing extradition to Spain under Franco if the Nazis invaded France – and was rejected for his 'extremist ideas and drift towards communism'.[5]

After all, Picasso's paintings are often rather extremist also, if we catch their drift. *Guernica* was never forgotten, or the reason for Picasso's joining the Communist Party, to show his opposition to Franco. In late October 1962, at the moment of the Cuban missile crisis, Picasso executed his *Rape of the Sabine Women* (Musée National d'Art Moderne, Paris), and in his notebooks picked up the figure of

the woman with a baby in her arms from *Guernica*, this time giving her two noses, and making other alterations. But the haunting by violence remains, and for his work of 1962 he asked Hélène Parmelin to find him reproductions of Jacques-Louis David's *Sabines* (1794–9) in the Louvre, and Nicolas Poussin's *Massacre of the Innocents*.[6] Painting was not to be separated from conscience, which has its own extremist ideas.

9

The South of France

If a work of art cannot live always in the present it must not be considered at all.[1]

'So, in the South of France, artists come to show their love of Spain, mistreated by the cowardly abandon of its republic, on the stone steps of the arenas where the spectacle of death conjured up in the bullfight lets them forget the barbarity recently evident in Europe.'[2] André Chastel goes on to describe how, for Picasso, as for André Masson, Michel Leiris and George Bataille, the bullfight crystallized the link of eroticism with death and that of both with the sun, aspiring to the impossibility of a fully unified universe, which more than ever would 'incarnate sacrifice in the tragic history of the civil war'. Masson, 'the matador painter', would illustrate Bataille's text about the sun and Mithraic ritual, also examined in a chapter of Leiris' *Age d'homme* and referred to in Leiris' poetry. It was Leiris who introduced Picasso to the arena at Nîmes. And after all, Picasso 'syncretises in *Guernica* the bullfight theme and the expression of revolt dear to Goya'.[3]

Such was the magnetism of Picasso's ideas that his friends, of all nations, were deeply and often immediately influenced by his affections. His British friend and patron Roland Penrose would write to him about attending bullfights in Spain, and his photographer wife Lee Miller, who had thought she would greatly dislike the spectacle, found herself riveted by it.

Picasso at a
bullfight, 1958.

Strange or perhaps not so very. 'No dialogue with the avant-garde had been possible to Picasso for years', begins one critic.[4] For in his last twenty years, Picasso was no longer a rebel, but rather a devotee of the classical masters, a line that would reach from Velázquez to the moderns. Obsessively, he repictured such paintings as Velázquez's *Las Meninas* (1656–7) in 1957; as Delacroix's *Women of Algiers* (1833), in the winter of 1954–5; and Manet's *Déjeuner sur l'herbe* (1863), repictured under the same title, as *Lunch on the Grass* (1961; Galerie Rosengart, Lucerne), and both referring back to Giorgione's *Concert champêtre* (1508–9). This bears witness to another side of him, that is, his loyalty to the past, which, along with his ease of variousness, gives a firm basis

to his modernism. They were also acts of homage, just as some of his statues, such as the *Flute Player* of 1950 (Musée Picasso, Paris), are homages to Matisse. But they are homages with a special exuberance. As Daix puts it, 'an "Anti-Classical" dimension – very Spanish in its taste for provocation, excess, and astonishment – was always a part of Picasso'.[5] These homages, whether spoken or unspoken, when they are not the obsessions of a series, do something quite unlike the rest of his work – they both refer and inaugurate. In any case, said Picasso about his meditations on traditional works, 'I've reached the moment, you see, when the movement of my thought interests me more than the thought itself.'[6]

Among the predecessors whose mobility of thought was so essential for Picasso, as for so many others – both observers and creators – was Paul Cézanne, never far from Picasso's mind. In 1958, when he visited the larger-than-life and massively knowledgeable collector Douglas Cooper at his Château de Castille, he was querying Cooper about what he might buy in the region. Cooper said the Château de Vauvenargues, in the valley under the Montagne Ste-Victoire, was for sale, the place where the moralist Vauvenargues had written his *Maximes*. Not only did the idea of living near Cézanne's mountain appeal to Picasso, but the notion of inhabiting a dwelling where a lot of moral thinking had gone on must also have appealed, just as the literary and political history of 7 rue des Grands Augustins had lent it a special attraction. At Vauvenargues, which he purchased in 1958, he painted his variations on Manet's *Déjeuner sur l'herbe* and *The Dead Toreador* (1864), of equal interest to the Spanish painter impassioned by bullfights. Picasso was never to sell Vauvenargues, where he wanted to be buried and was.

In 1959 André Malraux, the novelist and art historian, had been named Minister of Cultural Affairs. His admiration of Picasso ensured that the painter would have all possible venues for his exhibitions and all possible chances for various French prizes. It was in this year too that Picasso's *Monument to Apollinaire* (1928–9)

was finally erected, with its head of Dora Maar, originally cast in 1941.

In 1959 also the British art historian Roland Penrose had organized a major retrospective at the Tate, stretching from the year 1895 to 1959, and had prepared the catalogue. He had been planning, already in 1948, to have 'a confrontation between primitive art and modern art', as he wrote to Picasso. 'On the primitive side, prehistoric, oceanic and negro art, from the museums of Oxford, Cambridge, Brighton and the Musée de L'Homme. The centrepiece would be the *Demoiselles*, sent to us by MOMA, and three or four other important paintings by you . . . and some pottery.'[7]

His letter was reproduced in Christian Zervos's *Cahiers d'Art*, which also published Picasso's play *Desire Caught by the Tail*, for which Penrose was doing the preface. Modest as usual, Penrose lamented that his inexperience as a writer meant that it would lack brilliance. The preface began: 'Is it because life is too short and human powers too limited that poets are not often painters nor painter poets, or is there some contradiction . . . ?' Here Penrose quotes his friend Breton: 'An enterprise such as this requires all the resources of a passion self-sufficient, provided with a thousand tongues of fire'.[8] And then he lauds Picasso:

There is no barrier between the arts for Picasso. With prodigious talent, he has explored the possibilities of sculpture, photography, ceramics, lithography, and has in each case brought his own inventions and understood how to use the unfamiliar art so as to express more vigorously the drama of his perception of everyday life. Musicians are among his closest friends, and his love of music is expressed in the frequent appearance of musical instruments, particularly guitars and flutes, in his paintings.[9]

Penrose compared Picasso's play to William Blake's 'An Island in the Moon', and to Rimbaud's poems about the Seer, *Le Voyant*.

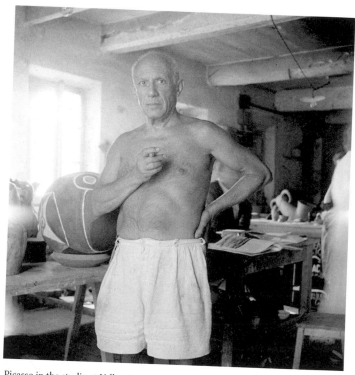
Picasso in the studio at Vallauris.

They were presented together at the Institute of Contemporary Art (ICA) in London, over which Penrose presided. It was an astounding success, according to Penrose, who sent Picasso the press clippings. Many were turned away at the door, and those within marvelled, said his British admirer.

Penrose enjoyed sending Picasso other things also, as well as rave reviews: for example, special coloured pencils he found, after much looking, in Lewes (the little Sussex town where Virginia and Leonard Woolf lived in Monk's House). To his feeling of closeness to Picasso – who had the rare ability to make his friends feel that intimacy with every contact, even when he himself did not write

often – his message of 4 February 1953 bears sufficient witness. It had been urgent for him to see Picasso, he says, because of Eluard's death and the pain he left. 'Only you had the magic to cure it.'[10] Even though he couldn't speak of it, that atmosphere created by Picasso was able, he says, to recharge his energy and his courage.

Picasso and Françoise Gilot had once visited him on Farley Farm, and it remained, says Roland Penrose, a celebrated date, like the Battle of Samothrace, the Armistice and the liberation of Paris (during which Picasso and Marie-Thérèse and their daughter Maia, born in 1935, were on the Ile St-Louis). And, of course, he and Lee Miller had visited Picasso here and there, in La Californie, near Cannes, and Sanary, near Marseille, as in other places, always with the same joy. Sometimes Penrose wrote from Farley Farm, sometimes from his house in London, or travelling (or vacationing on a beach somewhere, so they send him embraces 'with salty lips', in September 1956), sometimes under an official ICA letterhead: always with the same warmth.

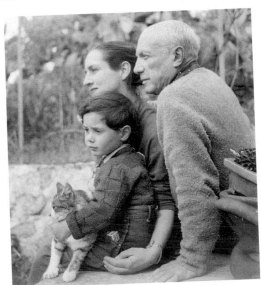

Picasso, Françoise Gilot and their son Claude.

For Picasso's 75th birthday the ICA was planning an exhibition that would include material from Sabartès, Kahnweiler and Man Ray, documents about friends such as Apollinaire, Max Jacob, Eluard, Cocteau and so on, and about the places he had worked. So, now in 1956, Penrose welcomed and displayed the photos of Picasso and Gary Cooper in Cannes, and of the Bâteau-Lavoir, taken from a carpenter's shop just overlooking the roofs. Scrupulous about everything, he was also anxious to get the right windows for Picasso's studio, asking Picasso to signal them on the photography, as he had done earlier for his studio in Avignon.[11] Picasso always sent whatever he was asked to, photographs of his work, brief texts, drawings, paintings, as those associated with him did not; Dora Maar, for example, upon occasion. She worried often about not getting things back in time, or perhaps ever – but then, Penrose's request for the exhibition came many years after her relationship with the painter had ended, so her hanging on to her treasures is understandable.

Penrose, occupied with many other things, was also hard at work on a biography of Picasso, having therefore every professional as

well as personal reason to see and write to him often. For him, it was always a 'whirlwind of work in the daytime, which only leaves the nights to continue my book'.[12] The last chapter of his biography ends with a description of *Las Meninas* (which was still in progress during his writing), making an end of what was not ended: all to the good, as both men believed. The book took three years of 'assiduous work', fully worth it because of Penrose's wish to make Picasso's work a bit more accessible to the Anglo-Saxons. And that he did.

In the meantime, Picasso had appeared in Clouzot's film *Le Mystère Picasso* (1955). Here you see him painting, at the speed of light. Those most overcome by the film, said Penrose, are the film critics, because they are so used to being unimpressed by painters, making their testimony all the more extraordinary. Picasso continued to contribute works to raise money for the ICA, giving to one picture fair the portrait of the painter-ape – it brought in more than £800, a massive amount for the time.

Despite the unfavourable site, the large panel that Picasso did for UNESCO with Icarus falling, which was on show in the summer of 1958, made a great impression on Penrose and his former wife Valentine, as well as on Lee and their son Tony:

> The black figure in the middle of the picture is well hidden when you come in, but at every step you take he seems to be falling from a distant sky until the moment when you are near enough to touch him, and then you see the whole picture with all those large figures dominating you. It has a dramatic quality I never noticed at Vallauris, being so beautiful when you see it as a whole, crushing you with its immense scale, and also when it is half hidden. So it triumphs over the circumstances in an amazing fashion, turning them to your advantage. I really find it a miracle.[13]

The image haunted Penrose, with its fall into the immense blue

wave: in fact, one of his own paintings with its upside-down figure may well bear its own witness to that haunting.

But the large Tate exhibition had its problems, because Douglas Cooper, who owned so many Picassos, was intractable. He had probably been hoping to be given the exhibition to organize, and was wounded, says Penrose, in a letter of 25 August 1958. Cooper had refused to be associated with it unless he could have control, and, furthermore, said he could not write for the catalogue unless he was to be well paid, because he was so occupied with his own books he was writing. (Penrose hadn't wanted to offer payment to such a 'grand seigneur'.) But even without his paintings, Penrose meant to make it an astonishing exhibition – he did just that.

In 1961 Picasso had married Jacqueline Roque, who was utterly devoted to him. Unlike Fernande and Olga and Dora and Françoise (and more in the line of Eva and Marie-Thérèse), Jacqueline put what the master wanted above everything else. She would not, like Fernande and Françoise, be writing memoirs that he would try to prevent being published. They would have no children.

In any case, Picasso's relation to his children and grandchildren left something to be desired. He was irascible, unfair and unforgiving. He would turn against Françoise's children, Claude and Paloma, after the publication of her book *Life with Picasso*, and more so still from Claude after the latter's court case against him, to ensure his own part of the heritage. He had turned away also from Marie-Thérèse's Maya, and Olga's son Paulo and his children Pablito and Marina, author of a scathing book about her grandfather. He had become a deliberate recluse.

For his 80th birthday in 1962, the Art Gallery of the University of California at Los Angeles organized an exhibition called *Bonne Fête Monsieur Picasso*. The Knoedler Gallery presented *Picasso: An American Tribute*, with a catalogue by John Richardson, and MOMA celebrated the birthday with a decor based on the *Fall of Icarus*, like his painting for UNESCO. Given Picasso's lifelong relation to the sun

and to Mithraic ritual of sun and sacrifice, the falling figure seems both ironic and appropriate, for he was deaf by this time, and preferred not to appear at his public celebrations. He was also suffering from prostate trouble, and was hospitalized for that in the American Hospital in Neuilly, near Paris.

In 1963, thanks to his other most devoted friend, Jaime Sabartès, the Museo Picasso opened in Barcelona, full of his early work. At the death of Sabartès in 1968, Picasso would give his series of *Las Meninas* to this museum in honour of his friend. 'These are not my works, they are my life', he said of his gifts to Barcelona. In 1961 he purchased his last dwelling, Notre-Dame-de-Vie, right above Cannes, near Mougins, and did his farewell drawings of La Californie. This year, in August, Picasso lost Braque – to whom his early commitment in the heyday of Cubism had somewhat waned; when he lost him at the train station in Avignon, he said, he never found him again. In October Cocteau died, having, in all his high dramatic mode, loved Picasso and been a good companion for his Pierrot and his Harlequin. One of Picasso's most memorable creations, his *Seated Pierrot*, perfectly represents, like the Harlequin, Picasso's lifelong dramatic figure. An actor always.

Françoise's memoir, published in 1964 in its French edition, over Picasso's strenuous objections, caused a rift between him and their children Claude and Paloma, and aroused the ire of quite a few in the art world, who objected just as strongly: as further witness, Dore Ashton's useful compendium of quotations explicitly leaves aside any from this volume. In this year Gallimard published Brassaï's riveting *Conversations avec Picasso*. Also in this year there appeared one of Picasso's most impressive renderings of *The Painter and His Model* (Mougins, 15 November), which must surely rank among the strongest pieces of Picasso's imagination for any observer: as Pierrot and Harlequin perfectly represent the painter as enactor of all his roles, light to tragic, the painter and his model

seize the moment of the truest act of all. Here eroticism and celebration merge, at the summit of seriousness.

Between 1965 and 1967 Picasso made his last trip to Paris, where many of the ballets he had designed sets and costumes for were performed (*Parade, L'Après-midi d'un faune, Le Tricorne*), André Breton died, and Malraux opened the exhibition *Homage à Picasso*; Picasso, of course, did not attend. He refused the French Légion d'honneur, not given to honours from a country not his Spain; was evicted from his beloved studio on the rue des Grands Augustins – why could Malraux not have designated the space where *Guernica* had been painted as historic, asks Penrose – and was miserable for a time at not being able to paint. He was awarded the Lenin peace prize, but did not receive the Russian ambassador – why should he make such an effort? – leaving Ilya Ehrenburg to accept it in his place.

At the Tate his sculpture and ceramics were shown, again thanks to Penrose, and the exhibition travelled to the Museum of Modern Art in New York. The exhibition of 'Late Picassos', in the Palais des Papes in Avignon, organized by Yvonne Zervos shortly before her death in January 1970, consisted of 167 oils, executed with an extraordinary verve between January 1969 and January 1970: an explosion of colour that lit up the dark interior of the palace from May to October, as anyone who attended it can testify. This was the year, too, that the venerable if rickety Bateau-Lavoir was destroyed by fire. Yvonne's husband, Christian, died in September, marking the end of an epoch: his *Cahiers d'Art* had published Picasso's poetry with Breton's salute to it,[14] and both the Zervos had marked with their generosity and spirit the entire art community from Paris to the Vaucluse.

In 1971 the ground-breaking *Guitar* construction of 1912 was given to MOMA, and, for Picasso's birthday, eight of his paintings were hung in the Grande Galerie of the Louvre, ensuring that he would yet again be breaking all traditions. One day, Picasso was

invited to choose, at George Salles' invitation, the paintings he most admired in the Louvre, to hang alongside his works: he chose Zurbarán, Delacroix, Courbet. And an Italian painter, asked Salles? To which Picasso replied: 'Only one – Uccello: the Rout of San Romano'. He wanted to see a Cubist painting hanging by its side. And Roland Penrose quotes him exclaiming in his excitement: 'You see it's the same thing! It's the same thing!'[15]

Patrick O'Brian, who had been in Avignon in 1969 and 1970, had gone to see the Picasso drawings hung in the chapel of Clement VI in the Palais des Papes, finding them, in their cold black and white, 'colder than the stone walls of the sacristy' with their brothel squalor. Picasso had spent his last years in isolation, unhappy, with a low opinion of himself, he wrote, and the exhibition had only confirmed this. So when he returned to Avignon in the autumn of 1972, he had hesitated. Then the surprise was glorious, as he went from the bright sunlit square outside the Palais into the Gothic darkness. There was the exhibition of the last works, a 'crowd of pictures blazing on the walls', with 'brilliant color everywhere, and springing life'. This is, he wrote, how late Picasso should be shown, in his intensely personal inventiveness, that single proof of genius he always had believed in. 'Free as the wind and happy: no one but a happy man could have painted those pictures, and no amount of verbal assurance could have been half so convincing.' This is how the writer saw the painter, and his life as a whole: 'his more than ordinary suffering and rebellion was counterbalanced, and I believe more than counterbalanced, by extraordinary satisfactions'.[16]

A personal note, about Avignon. When the poet René Char was asked by Picasso, shortly before his death, to write the catalogue piece for the exhibition in the Palais des Papes that would take place after the painter's death, he called it 'Picasso sous les vents étésiens' – 'Picasso under the summer winds'. In my small cabanon near L'Isle sur Sorgue, where Char lived, I went often to see him

when he was writing that piece, and when he came to see my family in that cabanon, he found the walls I had plastered just right for the hat worn by the child on the exhibition poster: it all seemed part of a whole, exactly what O'Brian had said about that blaze of colour in the Gothic space of the Palais des Papes.

When he was so very ill at the end of his life, Picasso remained curious about the doctor's instruments: he never lost that curiosity that had been the ruling feature, as I see it, of his life, with its cast of characters changing and his styles in all their celebrated variety. What he had remained most faithful to was his idea of friendship. On his deathbed, he talked to himself often about Apollinaire, who had been his most revered friend among the poets he loved. Apollinaire, who might be considered to have represented in poetry what Picasso represents in painting: the inventor of so much. A new order, said Apollinaire, who used everything in his poetry of everyday: snatches of conversation and images, making them into a collage of a high and new order – the very opposite of that 'return to order' demanded by the more conventional poets after the War. And that very everydayness is a significant part of what mattered to Picasso also. Here he is explaining about the ordinary objects in the still-life and his love for them. That is, he says, just it:

why I paint pipes, guitars or packages of tobacco and why these objects keep appearing in the canvases of contemporary painters . . . what could be more familiar to a painter, or painters of Montmartre or Montparnasse, than their pipe, their tobacco, the guitar hung over the couch, or the soda bottle on the café table?[17]

Towards the end, reaching out his hand to Jacqueline, Picasso said to the specialist who was by the bed: 'You are wrong not to marry. It's useful.' When he died, on 8 April 1973, no one was allowed to see him in his coffin. At his funeral, a few words were said over his

body by a priest, and by some local Communist councillors, and, concludes O'Brian, 'between them they lowered Picasso into his solitary grave, a man almost as lonely as the sun, but one who glowed with much the same fierce burning life'.[18]

Lonely in his genius, I would agree, but his interior and remembered friendships endured, and are, to my way of thinking, the great component of his art at its highest moments.

10

Conclusion

All I have ever made was made for the present and with the hope that it will always remain in the present.[1]

Picasso has catalysed and magnetized so many psychoanalytic interpretations that they may seem to cling to his work as to his person. I will take only two as examples, radically opposed and each full of potential for further reflection.

From the perspective of this twenty-first century, a reader of Carl Jung's reflections about Picasso, after the painter's retrospective at Zurich in 1932 (translated from the German for Zervos's *Cahiers d'Art*), might find it an illuminating contrast to so many gushing appraisals. That Jung should group the painter not with neurotics but with schizophrenics is not surprising, rather illuminating of Picasso's particular form of genius. He reflects on Picasso's mind as one in which the elements do not, in the long run, correspond to outward experience so much as to an inner unconsciousness. Whereas Picasso always said that he referred to his actual world, not to the abstract, the very intensity of his gaze and its result seem to stem from something else. In Jung's view, this was caused by some strangeness on the emotional level: not a 'single, harmonious feeling but rather contradictory emotions or even a complete absence of sensibility. From a strictly formal point of view, their predominant characteristic is that of an intellectual laceration, rendered by what are termed broken lines, that is to say, psychic

clefts or rents that traverse the image.' Thus the audacity of the impression, in which, says Jung, as with Joyce, 'nothing comes towards the observer; everything turns away from him'. For him, Picasso's paintings are about concealment, about a cold mist over an 'uninhabited bog: a play as it were that has no need of any audience'. He emphasizes the blue of Picasso's paintings, the blue 'of night, of water or of moonlight', like the 'blue of the Egyptian underworld'. As a sunlit life clings to him, he sees a dark soul sitting and waiting, with its forms given over to death, to the lower world, as he turns towards darkness, all this manifested by his 'broken lines, rags, faint remains, debris, and lifeless entities. Picasso and the exhibition of Picasso's works are, like the 28 thousand people who have seen them, transitory phenomena'.[2] Now, of course, Picasso's work was ongoing then, for almost another 40 years, but that makes the interpretation no less interesting.

Jung likens Picasso's Harlequins to that figure implicated in a murder, and the massive shapes to a 'grotesque primitive epoch, and, endowing them with cold, radiant light, brings back to life the soulless forms of Pompeian antiquity – a Giulio Romano could not have done worse'. (Worse? We admirers of Romano remain startled by the comparison.) But, for Jung, Picasso is only a 'chaotic diversity', in whose 'latest pictures the union of contraries is very clearly to be seen in their immediate juxtaposition . . . the light anima and the dark anima. The brilliant, clear-cut, and even violent colors of the most recent period correspond to the unconscious mind's tendency to overcome the conflict of the emotions'.[3]

In a completely different mode, Krauss's essay of 1985 against reading personal life into the artist's work, 'In the Name of Picasso', refers to the re-presentation of collage as a system in which the sign presupposes the absence of what is referred to and not its presence,[4] particularly in the case of Picasso. She criticizes the 'aesthetics of autobiography', in which art objects are taken as signifying a particular name ('Eva', 'Marie-Thérèse' or the 'Blonde Venus', as

she calls her), a sign (say, *jou* or *eau*) always signifies 'journal' – the newspaper, or Beaujolais the wine. 'The aesthetics of the proper name is erected specifically on the grave of form.'[5] This for her precisely undoes what collage does in a mode both revolutionary and transpersonal (as opposed to personal), and leaches out what matters, the play of differences, the 'literalization of depth' (where something is laid or stuck on top of something else) and the fullness of form.

And in *The Picasso Papers* of 1998, Krauss discusses Picasso's commitment to pastiche, after collage, as a reaction formation, and the latter as a

> hook that addicts him to secrecy, to the elaboration of a fanatically hidden life that is nonetheless extensively coded onto the entirely public surfaces of his painting, in just the style of the obsessional, whose ritualized behavior performs – in the modality of cleanliness – the very libidinally charged compulsions he has 'successfully' repressed.[6]

The hidden, the secret, the treasured thing not spoken of seems to guarantee the autonomy of the person hovering around it as a central issue. But the very non-referential character of the sign upon which the Cubist collage depends opens it to pastiche, like a currency suddenly emptied out.

Perhaps it has been Picasso's extreme and passionate contrasts and paradoxes, and his far-reaching variousness, that have so influenced not just the painters after him, but also the poets. From the impersonal experiments of Cubism, in which Picasso and Braque can be taken for each other, in that impassioned dialogue from 1907 to 1912, to the progressively more personal Picasso works – his long solo flight – his reach was nothing short of fabulous and fabled. He often spoke of himself and of his desire not ever to limit his audience to one or the other sector of opinion. Like Shakespeare

and Molière, he said, I mingle 'in my work often burlesque things and relatively vulgar things. In that way I reach everybody'.[7] And indeed he did, despite what Meyer Schapiro calls his 'self-closure and self-preoccupation'.[8] He easily reached the painters after him: by the collage form, the insertion of objects like newspapers into his paintings, and of words and phrases, or even half-words. At the new 're-moderning' of the Museum of Modern Art, as Arthur Lubow described it for the *New York Times Magazine* on 3 October 2004, Picasso could have gone in almost all the galleries, and might well have.

> In a kind of affirmative-action system to boost artists lacking the genius of Picasso, the team was always discriminating against the protean Spaniard. I saw a lineup of gallery alternates, all of them Picassos. The curators would joke about 'Picasso-free rooms' . . . 'It's just a monster threatening to eat every room,' [Ann] Temkin said only half-jokingly.

As for his influence, we might as well ask: who hasn't felt it? If we were to take only one painter, say, Robert Motherwell, it would be easy to point out how the labels of cigarette cases and book wrappers and the collage form in general provided inspiration, and how, in particular, the French phrases like 'Je t'aime Gaby' and the others were models for his own *Je t'aime* series. And this is so true for many painters of wildly different styles that, just as it is said that above the portal of every modern museum there should be the name 'Cézanne', so it is that for the twentieth century, there might be – on whatever portal or whatever lintel might be thought appropriate to our moment – the name Picasso.

In the end, the life attitude of this Spaniard was like that of the Englishman John Ruskin and the Frenchman Marcel Proust, who both had as their motto, explicit and implicit the warning – also a celebration – 'Work, Work, Work, for the night cometh when no

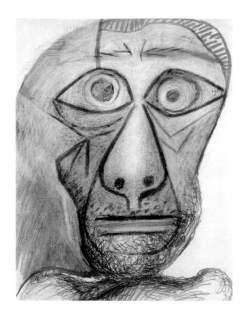

Self-portrait, 1972, pencil and wax crayon on paper.

man can work.' And Picasso: 'It's through one's work that one is understood. One must work, work.'[9] And when the night came, he had worked as hard and with as much passion as any living being – and with far more genius than other painters of his time. His art of friendship was a great part of this conviction, and his warmth in those friendships a great part of his genius.

Writing to Picasso, on 10 February 1925, Joan Miró summed up what many painters and poets felt about the painter who was Picasso: 'You did me so much good this morning. I'd rather walk my whole life in darkness provided that at the end I'd find some spark of pure light than to walk like all those young people in an artificial lighting'.[10] No matter how harsh, Picasso's light never seemed artificial, rather, an extraordinary outpouring and intertwining of a painter, his world and his friends.

References

1 Introduction

1 Dore Ashton, ed., *Picasso on Art: A Selection of Views* (New York, 1972), p. 38, from Sabartès.
2 André Malraux, *Picasso's Mask*, trans. June Guicharnaud with Jacques Guicharnaud (New York, 1974), pp. 18–19.
3 Lecture given on the occasion of the exhibition, at the Grand Palais, in March 2004.
4 Charles Baudelaire, *The Prose Poems and La Fanfarlo*, trans. Rosemary Lloyd (Oxford and New York, 1990), pp. 47–9.
5 Malraux, *Picasso's Mask*, p. 19.
6 Gertrude Stein, *Picasso* (New York, 1984), p. 90.
7 *Ibid.*, p. 5.
8 Elizabeth Cowling, *Picasso: Style and Meaning* (London, 2002), p. 5.
9 *Ibid.*, p. 17.
10 *Ibid.*, p. 18.

2 Picasso the Spaniard

1 Françoise Gilot, *Life with Picasso* (New York, 1989), p. 199.
2 Jack Flam, *Matisse/Picasso: The Story of their Rivalry and Friendship* (New York, 2003), p. 4.
3 Marilyn McCully, *Els Quatre Gats: Art in Barcelona around 1900* (Princeton, NJ, 1978), p. 18.
4 Patrick O'Brian, *Pablo Ruiz Picasso* (New York, 1976), p. 60.
5 Note in permanent exhibition at the Archives Picasso.

6 Flam, *Matisse / Picasso*, p. 4.

7 Cowling, *Picasso*, p. 101.

8 *Ibid.*, p. 111.

9 O'Brian, *Pablo Ruiz Picasso*, p. 89.

10 *Ibid.*, p. 94.

11 Elizabeth Cowling, *Picasso: Style and Meaning* (London, 2002), p. 145.

12 See Jonathan Brown, ed., *Picasso and the Spanish Tradition* (New Haven, CT, 1996).

13 *Ibid.*, pp. 61–94.

14 *Ibid.,*, p. 61.

15 *Ibid.*, p. 62.

16 *Ibid.*, p. 62.

3 Paris: The Bateau-Lavoir

1 Jack Flam, *Matisse / Picasso: The Story of their Rivalry and Friendship* (New York, 2002), p. 1.

2 Meyer Schapiro, *The Unity of Picasso's Art* (New York, 2000), p. 10.

3 Patrick O'Brian, *Pablo Ruiz Picasso* (New York, 1976), p. 175.

4 *Ibid.*, p. 130.

5 *Ibid.*, p. 97.

6 Emmanuelle Chevrière and Hélène Seckel, eds, *Max Jacob et Picasso*, exh. cat., Musée Picasso (Paris, 1994), p. 199.

7 *Ibid.*, p. 13.

8 *Ibid.*, p. 18.

9 Morris Bishop, ed., *A Survey of French Literature* (New York, 1965), vol. II, p. 33.

10 Chevrière and Seckel, *Max Jacob et Picasso*, p. 16.

11 *Ibid.*, p. 18.

12 *Ibid.*, p. 23.

13 André Salmon, *Souvenirs sans fin* (Paris, 1955), p. 510.

14 Chevrière and Seckel, *Max Jacob et Picasso*, p. 11.

15 *Ibid.*, p. 15.

16 *Ibid.*, p. 15.

17 *Ibid.*, p. 202.

18 O'Brian, *Pablo Ruiz Picasso*, p. 177.

19 Chevrière and Seckel, *Max Jacob et Picasso*, p. 140.
20 Brenda Wineapple, *Sister Brother: Gertrude and Leo Stein* (New York, 1996), p. 273.
21 John Richardson, *A Life of Picasso* (London, 1996), vol. II, p. 4.
22 Chevrière and Seckel, *Max Jacob et Picasso*, p. 140.
23 Richardson, *Life of Picasso*, vol. II, p. 3.
24 *Ibid.*, vol. II, p. 4.
25 *Ibid.*, vol. II, p. 3.
26 Brown, *Picasso and the Spanish Tradition*.
27 Flam, *Matisse / Picasso*, p. 32.
28 *Ibid.*, pp. 35–6.
29 *Ibid.*, p. 34.
30 O'Brian, *Pablo Ruiz Picasso*, p. 90.
31 Wineapple, *Sister Brother*, p. 243–4.
32 O'Brian, *Pablo Ruiz Picasso*, p. 8.
33 *Ibid.*, p. 155.
34 Gertrude Stein, *Picasso* (New York, 1984), p. 14.
35 *Ibid.*, p. 96.
36 *Ibid.*, p. 97
37 *Ibid.*, p. 4.
38 *Ibid.*, p. 27.
39 *Ibid.*, p. 13.
40 *Ibid.*, p. 76.
41 Chevrière and Seckel, *Max Jacob et Picasso*, p. 61.
42 Stein, *Picasso*, p. 37.

4 *Les Demoiselles d'Avignon* and the Beginnings of Cubism

1 John Richardson, *A Life of Picasso* (London, 1996), vol. II, p. 19.
2 Robert Hughes, *The Portable Picasso* (New York, 2003), p. 7.
3 Robert Rosenblum, *Cubism and Twentieth-Century Art* (New York, 1976), pp. 15–16.
4 Salmon, in Marilyn McCully, *A Picasso Anthology* (Princeton, NJ, 1982), p. 140.
5 Roland Penrose, *Picasso* (London, 1971), p. 60.
6 Richardson, *Life of Picasso*, vol. II, p. 19.

7 Brassai, *Picasso and Co.*, trans. Francis Price (Garden City, NY, 1966), p. 52.

8 Meyer Schapiro, *The Unity of Picasso's Art* (New York, 2000), p. 18.

9 Richardson, *Life of Picasso*, vol. II, p. 23.

10 Gasman, in *Picasso and the War Years, 1937–1945*, ed. Steven Nash and Robert Rosenblum (New York, 1999), p. 59.

11 André Malraux, *Picasso's Mask*, trans. June Guicharnaud with Jacques Guicharnaud (New York, 1974), p. 11.

12 In Christopher Green, *Les Demoiselles d'Avignon* (Cambridge, 2001).

13 Richardson, *Life of Picasso*, vol. II, p. 9.

14 Flam, *Matisse / Picasso*, p. 46.

15 Richardson, *Life of Picasso*, vol. II, p. 33.

16 Green, *Les Demoiselles d'Avignon*, p. 145.

17 Mark Polizzotti, *Revolution of the Mind: The Life of André Breton* (New York, 1995), p. 15; Michael Fitzgerald, *Making Modernism* (New York, 1995), p. 145.

18 Polizzotti, *Revolution of the Mind*, p. 24.

19 *Art News*, October 1972, p. 88.

20 Green, *Les Demoiselles d'Avignon*, pp. 9–10.

21 *Ibid.*, p. 43.

22 May 24th, 2004, pp. 32–4.

23 Malraux, *Picasso's Mask*, p. 23.

24 Schapiro, *Unity*, p. 13.

25 *Ibid.*, p. 23.

5 Poetic Cubism

1 Gertrude Stein, *Picasso* (New York), 1984, p. 5.

2 John Richardson, *A Life of Picasso* (London, 1996), vol. II, p. 97.

3 Elizabeth Cowling, *Picasso: Style and Meaning* (London, 2002), p. 97.

4 Stein, *Picasso*, p. 35.

5 Dore Ashton, ed., *Picasso on Art: A Selection of Views* (New York, 1972), p. 82.

6 Stein, *Picasso*, p. 36.

7 Supplement to *Transition*, 23. See the chapter on Stein in Dougald McMillan, *Transition, 1927–38: The History of a Literary Era* (New York, 1975) esp. pp. 176–7 for the Testimony.

8 Richardson, *Life of Picasso*, vol. II, p. 132.

9 Marilyn McCully, ed., *A Picasso Anthology: Documents, Criticism, Reminiscences* (Princeton, NJ, 1982), p. 64.

10 Timothy Hilton, *Picasso* (London, 1975), p. 153.

11 Gertrude Stein, *The Autobiography of Alice B. Toklas* (London, 1960), pp. 213–14.

12 Pierre Cabanne, *Le siècle de Picasso* (Paris, 1975), p. 272.

13 Pierre Reverdy, *Quelques poèmes, plupart du temps*, I: *Poésie* (Paris, 1969), pp. 65–6.

14 LeRoy C. Breunig, ed., *Apollinaire on Art: Essays and Reviews, 1902–1918* (New York, 1960), pp. 450–51.

15 Cendrars, *Poésie: 56: Le Panama; ou, les aventures de mes sept oncles; 61: Du monde entire* (Paris, 1967), p. 65.

16 Meyer Schapiro, *The Unity of Picasso's Art* (New York, 2000), p. 26.

17 Hilton, *Picasso*, p. 153.

18 *Ibid.*, pp. 120, 115.

19 Pierre Caizergues and Hélène Seckel, eds, *Picasso, Apollinaire: correspondance* (Paris, 1992), p. 113.

20 *Ibid.*, p. 106.

21 *Ibid.*, p. 55.

22 Published in *SIC*, no. 17 (May 1917).

23 Caizergues and Seckel, *Picasso, Apollinaire*, p. 103.

24 *Ibid.*, p. 106.

25 'La pipe et le pinceau'. Pipe: 'Je suis la forme même de la méditation / et finalement je ne contiens plus que des cendres / fumée trop lourde et ne peut plus que descendre'; Pinceau: 'Mais la main qui te prend contient L'UNIVERS / c'est immobiliser toute la vie / ici naissent / tous les aspects / tous les visages / et tous les / paysages, *ibid.*, p. 107.

26 *Ibid.*, p. 16.

27 *Ibid.*, p. 21.

28 *Les Archives de Picasso* (Paris, 2003), p. 106.

29 *Ibid.*, p. 107.

30 *Ibid.*, p. 109.

31 *Ibid.*, p. 110.

32 Richardson, *Life of Picasso*, vol. II, pp. 176–8.

33 Rosalind Krauss, *The Picasso Papers* (New York, 1998), p. 28.

34 *Ibid.*, p. 55.

35 Picasso, reported by Kahnweiler; Ashton, *Picasso on Art*, p. 116.

36 Stein, *Picasso*, p. 36.

37 Cowling, *Picasso*, p. 98.

38 Emmanuelle Chevrière and Hélène Seckel, eds, *Max Jacob et Picasso*, exh. cat., Musée Picasso (Paris, 1994), p. 222.

39 Flam, *Matisse / Picasso*, p. xi.

40 Max Jacob, *Correspondances 51: Les amities et les amours*, ed. Didier Gomper Netter (Paris, n.d.), p. 112.

41 Jacob, *Correspondances*, p. 222.

42 Chevrière and Seckel, *Max Jacob et Picasso*, p. 128.

43 *Ibid.,*, p. 117.

44 Jacob, *Correspondances*, p. 221.

45 Chevrière and Seckel, *Max Jacob et Picasso*, pp. 221–2.

46 *Ibid.*, p. 287.

47 *Ibid.*, p. 262.

48 Jacob, *Correspondances*, p. 246

49 *Ibid.*, p. 262.

50 Chevrière and Seckel, *Max Jacob et Picasso*, p. 274.

51 Kenneth E. Silver, *Esprit de Corps: The Art of the Parisian Avant-Garde and the First World War, 1914–1925* (Princeton, NJ, 1989), p. 3.

6 The Ballets Russes

1 Dore Ashton, ed., *Picasso on Art: A Selection of Views* (New York, 1972), p. 38.

2 Kenneth E. Silver, *Esprit de Corps: The Art of the Parisian Avant-Garde and the First World War, 1914–1925* (Princeton, NJ, 1989), p. 68.

3 Silver, *Esprit de Corps*, p. 71.

4 *Ibid.*, p. 108.

5 John Richardson, *A Life of Picasso* (London, 1996), vol. II, p. 181.

6 Letter from Jacob to Jacques Maritain, Patrick O'Brian, *Pablo Ruiz Picasso* (New York, 1976), p. 219.

7 Richardson, *Life of Picasso*, vol. II, p. 380.

8 Jean-Yves Tadié, *Marcel Proust: A Life*, trans. Euan Camercon (New York, 2000), p. 76.

9 *Les Archives de Picasso* (Paris, 2003), p. 220.

10 Elizabeth Cowling, *Picasso: Style and Meaning* (London, 2002), p. 334.

11 Unpublished letter, Archives Picasso, 18 April 1917.

12 *Ibid.*, 17 April 1917.

13 *Ibid.*, 10 September 1923.

14 *Ibid.*, no date.

15 Cowling, *Picasso*, p. 330.

16 *Ibid.*, p. 331.

17 Pierre Daix, *Picasso: Life and Art*, trans. Olivia Emmet (London, 1994), p. 172.

18 Daix, *Picasso*, p. 172.

19 Richardson, *Life of Picasso*, vol. II, p. 422.

20 Daix, *Picasso*, p. 155.

21 Silver, *Esprit de Corps*, pp. 119–26.

22 Richardson, *Life of Picasso*, vol. II, p. 432.

23 O'Brian, *Pablo Ruiz Picasso*, p. 237.

24 Tadié, *Marcel Proust*, p. 693.

25 O'Brian, *Pablo Ruiz Picasso*, p. 254.

26 *Ibid.*, p. 383.

27 Mary Ann Caws with Sarah Bird Wright, *Bloomsbury and France: Art and Friends* (New York, 2000), p. 79, quoted from Michael Holroyd, *Lytton Strachey: The New Biography* (London, 1994), p. 452.

28 Quoted in Caws and Wright, *Bloomsbury and France*, p. 82.

29 Caws and Wright, *Bloomsbury and France*, pp. 82–3.

30 Unpublished letter, Archives Picasso, (no specific date given).

31 *Les Archives de Picasso*, p. 227.

32 Unpublished letter, Archives Picasso, 1926 (no specific date given).

33 *Les Archives de Picasso*, 5 December 1928, p. 227.

7 Surrealism

1 Dore Ashton, ed., *Picasso on Art: A Selection of Views* (New York, 1972), p. 72.

2 Roland Penrose, *Picasso* (London, 1981) p. 86.

3 Kenneth E. Silver, *Esprit de Corps: The Art of the Parisian Avant-Garde and the First World War, 1914–1925* (Princeton, NJ, 1989), pp. 314–16.

4 Chevrière and Seckel, *Max Jacob and Picasso*, p. 147.

5 *Cahiers d'Art*, 1936, nos. 7–10.

6 Ashton, *Picasso on Art*, p. 130.

7 *Picasso: Collected Writings*, ed. Marie-Laure Bernadac and Christine Piot, trans. Carol Volk and Albert Bensoussan (New York, 1989), p. viii.

8 *Ibid.*, p. ix.

9 *Ibid.*, p. xxx.

10 Arnold Glimcher and Marc Glimcher, eds, *Je suis le Cahier: The Sketchbooks of Picasso* (New York, 1986), p. 114.

11 20 December 1946, in *Les Archives de Picasso* (Paris, 2003), p. 202.

12 *Les Archives de Picasso*, 3 January 1947, p. 204.

13 Unpublished letter, Archives Picasso, 8 January 1945.

14 All in Archives Picasso.

15 Postcard from Cortina d'Alprezzo, 19 August 1936, Archives Picasso, 97.

16 Unpublished letter, Archives Picasso, no date.

17 Unpublished letter, Archives Picasso, no date.

18 *Les Archives de Picasso*, p. 99.

19 Postcard from Cadaquès, October 1949, Archives Picasso, 99, my translation.

20 Pierre Daix, *Picasso: Life and Art*, trans. Olivia Emmet (London, 1994), p. 204.

21 Glimcher and Glimcher, *Je suis le Cahier*, p. 121.

22 Daix, *Picasso*, p. 174.

23 Pierre Reverdy, *Selected Poems*, ed. and trans. John Ashbery, Mary Ann Caws and Patricia Terry (Winston-Salem, NC, 1991), pp. 24–6.

24 Unpublished document, in exhibition *De la Celestina à Dora Maar*, Musée Picasso, Paris, trans. Mary Ann Caws, *Picasso's Weeping Woman: The Life and Work of Dora Maar* (Boston, MA, 2000), p. 96.

25 Brassai, *Picasso and Co.*, trans. Francis Price (Garden City, NY, 1966),p. 10.

26 *Le Surréalisme et la peinture* (Paris, 1928, 1965); trans as *Surrealism and Painting* by Simon Watson Taylor (Boston, MA, 2002), p. 101.

27 Elizabeth Cowling, *Picasso: Style and Meaning* (London, 2002), p. 101.

28 André Breton, *Mad Love*, trans. Mary Ann Caws (Lincoln, NE, 1987), p. 7, note 8.

29 Ashton, *Picasso on Art*, p. 65.

30 Breton, *Surrealism and Painting*, p. 101.

31 *Ibid.*, p. 113.

32 *Les Archives de Picasso*, p. 212.

33 Patrick O'Brian, *Pablo Ruiz Picasso* (New York, 1976), p. 212.

34 Martica Sawin, *Surrealism in Exile and the Beginnings of the New York School* (Cambridge, MA, 1995)

35 *Les Archives de Picasso*, p. 218.

36 Max Jacob, *Correspondances: Les amitiés et les amours*, ed. Didier Gomper Netter (Paris, n.d.), p. 268.

8 *Guernica* and the Party

1 Picasso prose poem, 6 January 1940; in Mary Ann Caws, *Dora Maar With and Without Picasso: A Biography* (London, 2000).

2 *Cahiers d'Art*, XII/4–5 (1937).

3 Caws, *Dora Maar*, p. 10.

4 See Michael Fitzgerald's book on *The Artist's Studio* (New Haven, 2001), in conjunction with the Wadsworth Museum and an exhibition devoted to just that theme.

5 *The Week*, 30 April 2004.

6 Arnold Glimcher and Marc Glimcher, eds, *Je suis le Cahier: The Sketchbooks of Picasso* (New York, 1986), pp. 179–88.

9 The South of France

1 Dore Ashton, ed., *Picasso on Art: A Selection of Views* (New York, 1972), p. 5.

2 Patrick O'Brian, *Pablo Ruiz Picasso* (New York, 1976), p. 9.

3 *Ibid.*, p. 15.

4 *Ibid.*, p. 272.

5 Pierre Daix, *Picasso: Life and Art*, trans. Olivia Emmet (London, 1994), p. 364.

6 Elizabeth Cowling, *Picasso: Style and Meaning* (London, 2000), p. 657.

7 Penrose to Picasso, 11 October 1948.

8 Penrose, preface to the translation of Picasso's play *Desire Caught by the Tail*, in which he quotes Breton, from his encomium to Picasso in 'Picasso Poète', *Cahiers d'art*, nos 7–10 (1935).

9 Penrose, preface.

10 Penrose to Picasso, unpublished letter, 4 February 1953, © The Estate of

Roland Penrose, 2005.

11 Penrose to Picasso, unpublished letter, 7 August 1956.

12 Penrose to Picasso, 21 September 1957.

13 Penrose to Picasso, Montpellier, 21 October 1958.

14 *Cahiers d'art*, nos 7–10.

15 Penrose, *Picasso*, p. 466. [AQ; which Penrose ref?]

16 O'Brian, *Pablo Ruiz Picasso* p. 478.

17 Ashton, *Picasso on Art*, p. 35.

18 O'Brian, *Pablo Ruiz Picasso* p. 480.

10 Conclusion

1 Dore Ashton, ed., *Picasso on Art: A Selection of Views* (New York, 1972), p. 5.

2 Jung in Patrick O'Brian, *Pablo Ruiz Picasso* (New York, 1976), pp. 488–92.

3 *Ibid.*, p. 488.

4 Rosalind E. Krauss, *The Originality of the Avant-Garde and Other Modernist Myths* (Cambridge, MA, 1985), esp. pp. 33–6.

5 *Ibid.*, p. 39.

6 Rosalind Krauss, *The Picasso Papers* (New York, 1998), p. 240.

7 O'Brian, *Pablo Ruiz Picasso*, p. 445.

8 Meyer Schapiro, *The Unity of Picasso's Art* (New York, 2000), p. 42.

9 Ashton, *Picasso on Art*, p. 36.

10 *Les archives de Picasso* (Paris, 2003), p. 140.

Bibliography

By Picasso and Friends

Les Archives de Picasso (Paris, 2003)

Dore Ashton, ed., *Picasso on Art: A Selection of Views* (New York, 1972)

Marie-Laure Bernadac and Christine Piot, eds, *Picasso: Collected Writings*, trans. Carol Volk and Albert Bensoussan (New York, 1989)

Pierre Caizergues and Hélène Seckel, eds, *Picasso, Apollinaire: correspondance* (Paris, 1992)

Emmanuelle Chevrière and Hélène Seckel, eds, *Max Jacob et Picasso*, exh. cat., Musée Picasso (Paris, 1994)

Marilyn McCully, ed., *A Picasso Anthology: Documents, Criticism, Reminiscences* (Princeton, NJ, 1982)

Collections

Jonathan Brown, ed., *Picasso and the Spanish Tradition* (New Haven, CT, 1996)

Jean Clair, ed., *Picasso: sous le soleil de Mithra* (Paris, 2001)

Arnold Glimcher and Marc Glimcher, eds, *Je suis le Cahier: The Sketchbooks of Picasso* (New York, 1986)

Brigitte Léal *et al.*, *The Ultimate Picasso* (New York, 2000)

Steven Nash and Robert Rosenblum, eds, *Picasso and the War Years, 1937–1945* (New York, 1999)

Other Relevant Works

Anne Baldassari, *Picasso and Photography: The Dark Mirror*, trans. Deke
 Dujsinberre (Houston, TX, 1997)
Charles Baudelaire, *The Prose Poems and La Fanfarlo*, trans. Rosemary Lloyd
 (Oxford and New York, 1990)
John Berger, *The Sense of Sight* (New York and London, 1985)
—, *The Success and Failure of Picasso* (Harmondsworth, 1965)
Brassaï, *Picasso and Co.*, trans. Francis Price (Garden City, NY, 1966)
André Breton, *Mad Love*, trans. Mary Ann Caws (Lincoln, NE, 1987)
—, *Surrealism and Painting*, trans. Simon Watson Taylor (Boston, MA, 2002;
 originally published as *Le Surréalisme et la peinture*, Paris, 1928)
Pierre Cabanne, *Le siècle de Picasso* (Paris, 1975)
Mary Ann Caws, *Dora Maar With and Without Picasso: A Biography* (London,
 2000)
—, ed. and trans. *Surrealist Love Poems* (London, 2001)
—, with Sarah Bird Wright, *Bloomsbury and France: Art and Friends* (New York,
 2000)
Elizabeth Cowling, *Picasso: Style and Meaning* (London, 2002)
Pierre Daix. *Picasso: Life and Art*, trans. Olivia Emmet (London, 1994)
Guy Davenport, *The Death of Picasso: New and Selected Writing* (New York,
 2005)
Paul Eluard, *Choix de Poèmes*, ed. Alain Bosquet (Paris, 1951)
Michael Fitzgerald, *Making Modernism* (New York, 1995)
—, *Picasso: The Artists' Studio* (New Haven, 2001)
Jack Flam, *Matisse / Picasso: The Story of their Rivalry and Friendship* (New
 York, 2003)
Judi Freeman, *Picasso and the Weeping Women: The Years of Marie-Thérèse
 Walter and Dora Maar*, exh. cat., Los Angeles County Museum of Art
 (1994)
Françoise Gilot and Carlton Lake, *Life with Picasso* (New York, 1964)
Christopher Green, *Les Demoiselles d'Avignon* (Cambridge, 2001)
Timothy Hilton, *Picasso* (London, 1975)
Robert Hughes, ed., *The Portable Picasso* (New York, 2003)
Max Jacob, *Correspondances: les amities et les amours*, ed. Didier Gomper Netter
 (Paris, n.d.)
Rosalind E. Krauss, *The Originality of the Avant-Garde and Other Modernist*

Myths (Cambridge, MA, 1985)

—, *The Optical Unconscious* (Cambridge, MA, 1993)

—, *The Picasso Papers* (New York, 1998)

James Lord, *Picasso and Dora: A Memoir* (London, 1993)

Annie Maillis, *Picasso et Leiris dans l'Arène: les écrivains, les artistes et les toros (1937–1957)* (Paris, 2002)

André Malraux, *Picasso's Mask*, trans. June Guicharnaud with Jacques Guicharnaud (New York, 1974)

Marilyn McCully, *Els Quatre Gats: Art in Barcelona around 1900* (Princeton, NJ, 1978)

Patrick O'Brian, *Pablo Ruiz Picasso* (New York, 1976)

Fernande Olivier, *Picasso and his Friends*, trans. Jane Miller (New York, 1965; originally published as *Picasso et ses amis*, Paris, 1933)

Hélène Parmelin, *Picasso Says . . .* , trans. Christine Trollope (London, 1969; originally published as *Picasso Dit*, Paris, 1966)

Roland Penrose, *Picasso: His Life and Work* (London, 1981)

Mark Polizzotti, *Revolution of the Mind: The Life of André Breton* (New York, 1995)

Christopher Reed, *Bloomsbury Rooms: Modernism, Subculture and Domesticity* (New Haven and London, 2004)

Pierre Reverdy, *Selected Poems*, ed. and trans. John Ashbery, Mary Ann Caws and Patricia Terry (Winston-Salem, NC, 1991)

John Richardson, *A Life of Picasso*, 3 vols (London, 1996)

Bernice Rose, *Picasso: 200 Masterpieces, from 1898–1972* (Boston, MA, 2002)

Robert Rosenblum, *Cubism and Twentieth-Century Art* (New York, 1976)

William Rubin, *Picasso and Braque* (Paris, 1989)

André Salmon, *Souvenirs sans fin* (Paris, 1955)

Martica Sawin, *Surrealism in Exile and the Beginnings of the New York School* (Cambridge, MA, 1995)

Meyer Schapiro, *The Unity of Picasso's Art* (New York, 2000)

Kenneth E. Silver, *Esprit de Corps: The Art of the Parisian Avant-Garde and the First World War, 1914–1925* (Princeton, NJ, 1989)

Gertrude Stein, *Picasso* (New York, 1984)

—, *The Autobiography of Alice B. Toklas* (London, 1960)

Jean-Yves Tadié, *Marcel Proust: A Life*, trans. Euan Camercon (New York, 2000)

Brenda Wineapple, *Sister Brother: Gertrude and Leo Stein* (New York, 1996)

Acknowledgements

I want first of all to thank Hélène Seckel, Anne Baldassari and especially Sylvie Fresnault of the Archives Picasso, for their encouragement and crucial assistance with this book, and with my work in the Archives during my research for *Dora Maar – With and Without Picasso: A Biography* (London, 2000).

My thanks for their permission to publish the letters which fall under their jurisdiction to the Archives Picasso and the copyright holders of the letters, to Pierre Bergé, President of the Comité Jean Cocteau, to Serge Malausséna for the letters from Antonin Artaud, to Antony Penrose for permission to quote the letters of his father, Roland Penrose, and to the Fundaçio Gala-Salvador Dalí for their permission to quote the letters of Salvador Dalí.

Photographic Acknowledgements

The author and publishers wish to express their thanks to the below sources of illustrative material and/or permission to reproduce it (in some cases locations of items are also given):

Fuji Television Gallery, Tokyo: p. 154; Philadelphia Museum of Art: p. 108 (A. E. Gallatin Collection, photo Graydon Wood); photos Rex Features: pp. 6 (Star Press, 33130A), 85 (SIPA Press, 162593B), 137 (Roger-Viollet, 458185T); photos Rex Features/Roger Viollet: pp. 10 (RV 317271, Musée Picasso, Paris, photo © Collection Roger Viollet), 13 (RV 13957-7, Museu Picasso, Barcelona, photo © Collection Roger Viollet), 15 (RV 13957-3, Museu Picasso, Barcelona, photo © Collection Roger Viollet), 30 (RV 10404-1, Art Institute of Chicago, Bartlett collection, photo © Collection Roger Viollet), 36 (RV 2412-12, photo © Harlingue/Roger-Viollet), 45 (RV 10943-1, Metropolitan Museum of Art, New York, photo © Collection Roger Viollet), 50 (RV 747-6, Museum of Modern Art, New York, photo © Collection Roger Viollet), 70 (RV 1478-16, Musée National d'Art Moderne, Paris, photo © Harlingue/Roger-Viollet), 87 (RV 1131-9, photo © Collection Roger Viollet), 90 (RV 1106-11, Musée Picasso, Paris, photo © Collection Roger-Viollet), 91 (RV 2174-15, Musée Picasso, Paris, photo © Lipnitzki/ Roger-Viollet), 97 (RV 1492-7, photo © Harlingue/Roger-Viollet), 106 (RV 5516-5, photo © Lipnitzki/Roger-Viollet), 111 (RV 696-8, photo © Lipnitzki/Roger-Viollet), 126 (RV 663-10, photo: © Collection Roger-Viollet), 140 (RV 1798-14, photo © Lipnitzki/Roger-Viollet), 141 (RV 2112-4, photo © Lipnitzki/Roger-Viollet), 142 (RV 5721-1, photo © Collection Roger-Viollet); Photos RMN: pp. 29 (Musée Picasso, Paris; photo Franck Raux), 62 (Musée Picasso, Paris; photo René-Gabriel Ojéda); State Hermitage Museum, St Petersburg: p. 59. All works by Picasso are © Succession Picasso/DACS 2005.